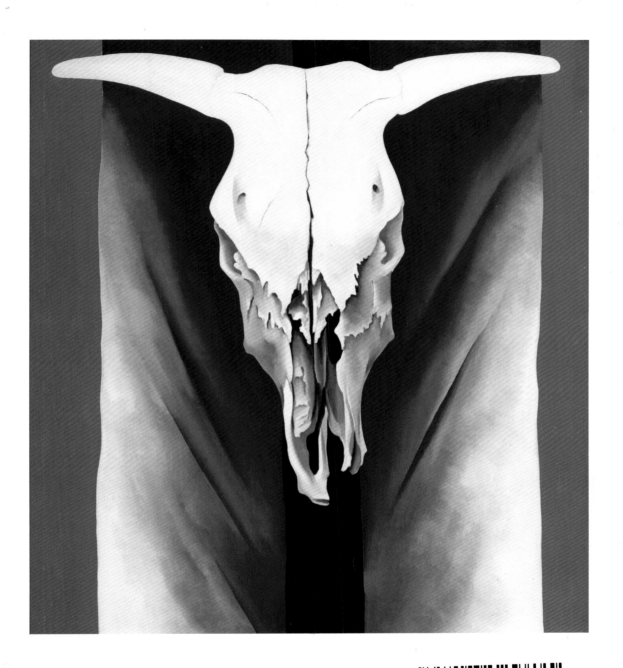

D1423098

GEORGIA

RANDALL GRIFFIN

PHAIDON · FOCUS

Φ

ICON OF AMERICAN MODERNISM

The American painter Georgia O'Keeffe (1887–1986) was a pioneering figure who opened new spaces of possibility for the women who succeeded her. At a time when the art world was dominated and defined by men, she was exceptionally well-known and lionized. In her lifetime, O'Keeffe's work was almost always viewed as quintessentially 'feminine'. But we should beware of reducing her to a stereotype.

Simply put, O'Keeffe deserves attention because she was one of the most original painters of her generation. With her remarkable flower paintings, for example, she transformed the genre through her capacious sense of the intimate. She also breathed new life into the tradition of picturing the American West through her Surrealist-inspired renderings of skulls and pelvises. While it is true that nature captured the imagination of many contemporary painters, photographers and sculptors, no other artist from the first half of the twentieth century explored it more widely or with such a distinctive voice.

It is easy to forget that when O'Keeffe came of artistic age in the 1920s, America was generally inhospitable to modern art. Yet she was remarkably successful as a painter, ultimately more so than any of her modernist American contemporaries. With her gift for vivid, lucid design, her unabashed love of brightly coloured decorative forms and her frequent coupling of abstraction with realism, she made modernism accessible to a broad at home audience. As a result of this popularity, her work has become so familiar and widely seen, that one could overlook its complexity and richness.

O'Keeffe had an uneasy relationship with twentieth-century avant-garde art. She was, in essence, an heir to the late nineteenth-century traditions of 'Art for Art's Sake' – where art need not have a purpose but was of value in its own right – and Symbolism, whose aim was not to depict, but to suggest the subjective ideas of the painter. She had an unshakable faith in art's ability to convey inner feelings, which was a major tenet of Symbolism. Nature was a deep well for her, and she found equivalents for emotions in natural forms. She cherished stones, shells and bones that she collected on her travels, objects that found prominent places in her houses and were reproduced in her pictures. In the same way as smooth river rocks are inviting to hold, her paintings often reflect the enjoyment of touch as well as sight. In her work, the natural world elicits surprises. For instance, her portrayals of flowers or the much-enlarged bones of a mouse create Lilliputian vantage points. Like the English Romantic poets and American transcendentalists, O'Keeffe prized nature for evoking wonderment, as a place of refuge and a means to explore the inner self.

◄ Georgia O'Keeffe, photographed by Alfred Stieglitz, 1918.

EARLY LIFE AND ART

Georgia O'Keeffe was born on 15 November 1887 near the small town of Sun Prairie, Wisconsin. Her parents, Ida Totto O'Keeffe and Francis Calyxtus O'Keeffe, were dairy farmers and her early rural life left an indelible impression. As O'Keeffe later noted, 'Where I come from, the earth means everything.' An independent child, she disliked school in general but relished her art classes. In 1902 her parents decided to move away from Wisconsin's brutal winters to the warmer climate of Williamsburg, Virginia, where her father started a grocery and feed store.

ART TRAINING

O'Keeffe moved to Chicago in autumn 1905 to attend the Art Institute, a school that then emulated the conservative École des Beaux-Arts in Paris. She enrolled in the Art Institute's programme, which was designed to train art teachers, and spent two semesters there.

In 1907, at the age of nineteen, she studied at the progressive Art Students League in New York City for one year. O'Keeffe's favourite instructor was William Merritt Chase (1849–1916), a brilliant painter and charismatic teacher. One of the few surviving paintings that O'Keeffe produced while at the Art Students League is an untitled still life of a dead rabbit with a copper pot from 1908, which mimics Chase's still lifes. O'Keeffe's painting convincingly evokes the contrast between the rabbit's soft fur and the hard, smooth surface of the metal pot. It was awarded the League's prestigious Chase Award, which may help to explain her career-long love of still life.

By autumn 1908, O'Keeffe needed a job and decided to become a commercial artist. She spent the following two years working as a freelance illustrator in Chicago. During that period she abandoned her own art entirely, instead focusing her creative energies on her commercial activity. Her interest in the making of art was later revived by a class for art teachers that she took in summer 1912 with Alon Bement (1876–1954) at the University of Virginia.

MENTORS BEMENT AND DOW

Bement was an enthusiastic follower of his mentor Arthur Wesley Dow (1857–1922), a Paris-trained artist with a passion for Japanese art (in particular Ukiyo-e prints and ink paintings) that was founded on real erudition. Director of the Department of Fine Arts at Columbia University's Teachers College in New York (where O'Keeffe would later take classes), Dow had a major influence on many artists, including O'Keeffe, mainly through his book, *Composition* (1899).

[5]

◀ O'Keeffe at the University of Virginia, summer of 1915.

Dow freed O'Keeffe to take her work in a new direction. As she wrote, 'The way you see nature depends on whatever has influenced your way of seeing. I think it was Arthur Dow who affected my start, who helped me to find something of my own.' His ideas remained alive in her painting until the end of her life, especially his belief that compositions should be unified, that line should be infused with a 'mental force', and that pictorial space should be filled with beautiful forms.

TEACHING IN TEXAS

After the class with Bement at the University of Virginia, O'Keeffe accepted her first full-time teaching job, starting in autumn 1912 as Head of the Art department of the public schools in Amarillo, Texas. O'Keeffe had been introduced to the American West as a child through the 'dime-store' novels that celebrated the danger-filled adventures of men such as Billy the Kid and Kit Carson. As O'Keeffe noted, 'I was hugely excited about going to Texas, because of all those stories that Mother had read to us. Texas was the great place in the world as far as I was concerned.' She relished the sweeping vistas there, saying that 'the wind blows like mad – and there is nothing after the last house of town as far as you can see – there is something wonderful about the bigness and the loneliness and the windyness of it all'. During her two years in Amarillo, O'Keeffe began wearing her austere but comfortable handmade black dresses, with flat shoes and little or no jewellery.

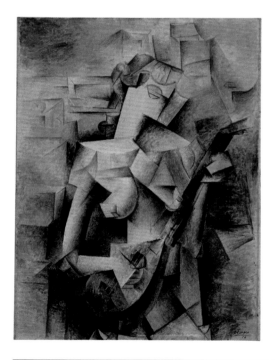

1
Pablo Picasso (1881–1973)
Girl with a Mandolin, 1910
Oil on canvas
100.3 × 73.6 cm (39 ½ × 29 in)
The Museum of Modern Art, New York

2
Louis H. Sullivan
(1856–1924)
Carson Pirie Scott and
Company Store, exterior
detail, Chicago, 1899
Glass negative
20.3 × 25.4 cm
(8 × 10 in)
The Art Institute
of Chicago

MODERNIST INFLUENCES IN NEW YORK CITY

O'Keeffe's teaching job in Amarillo required her to take additional classes to complete her teacher's training degree, so in autumn 1914 she enrolled at Teachers College, Columbia University (where Bement and Dow taught), in New York City, eventually spending three semesters there. O'Keeffe took a printmaking class with Dow, which he taught in the 'Japanese manner', emphasizing the importance of decorative abstract design.

During autumn 1914 and spring 1915, O'Keeffe saw several exhibitions of modern art. She had missed the famed Armory Show in New York in 1913, but she did visit a Matisse exhibition at Montross Gallery and a show of Cubist works by Pablo Picasso (1881–1973) and Georges Braque (1882–1963) at Alfred Stieglitz's 291 gallery, an incubator for American modernism. Moreover, Bement introduced her to Arthur Jerome Eddy's newly published pioneering survey of early modernism, *Cubists and Post-Impressionism*, so by spring 1915 she had been exposed to its major figures and styles. The small still life that she painted in 1914 is evidence of this. The picture's mosaic-like appearance – with its bright red horse, acid-yellow plate and vivid green ball – was derived most specifically from Pointillism, in which pigment was applied in dots, rather than blended. For O'Keeffe, works like this declared that she was no longer under the shadow of her former teacher, Chase.

[6]

SOUTH CAROLINA DRAWINGS

In autumn 1915, O'Keeffe moved to Columbia, South Carolina, to teach at Columbia College, a two-year Methodist women's college that trained art teachers. She spent most of a year there, where her isolation elicited a burst of creativity in the form of a daring group of abstract charcoal and pastel drawings, including *Early No. 2*.

[10]

These charcoals were breakthrough works that represent a seismic shift in O'Keeffe's art. She noted: 'I decided to start anew – to strip away what I had

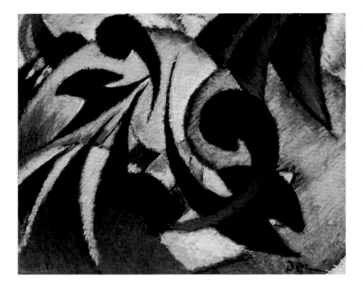

3
Arthur Dove (1880–1946)
Nature Symbolized No. 2, c.1911
Pastel on paper
45.8 × 55 cm (18 × 21 ⅝ in)
The Art Institute of Chicago

been taught – to accept as true my own thinking ... I began with charcoal and paper and decided not to use any color until it was impossible to do what I wanted to do in black and white.' She wrote that the drawings were based on 'things in my head that are not like what anyone has taught me'. Yet, as many have observed, they bear unmistakable traces of an array of sources. For instance, the monochromatic and faceted *Early No. 2* hints at early Cubist paintings by Picasso and others. [1]

With their circuitous lines, O'Keeffe's charcoals are also informed by Art Nouveau. She admired the stylized illustrations of Aubrey Beardsley (1872–1898), whom she emulated at times in pen-and-ink figurative works, and she would also have been familiar with the modernist architect Louis Sullivan's architectural reliefs in Chicago. In the 1910s, O'Keeffe [2] created several pastels and watercolours that are animated by sinuous lines. Some, such as *No. 32 – Special*, capture the fluidity of water, whilst others [7] evoke fiddlehead ferns about to unfurl. [8]

The art historian Sarah Whitaker Peters has argued convincingly that allusions to water in the South Carolina works should be understood as a metaphor for the realm of the imagination (as O'Keeffe said, 'things in my head'). The association between water and the imagination was a common theme in Art Nouveau, particularly in the medium of glass. Of course, the stylized depiction of water was already an established genre in late nineteenth-century modernist painting as well, for example in the works of Claude Monet (1840–1926), Edvard Munch (1863–1944) and Paul Gauguin (1848–1903).

O'Keeffe's abstract charcoals also have affinities with a group of pastels by Arthur Dove from 1911–12. A painter in the Stieglitz circle, Dove sought [3] (not unlike John Marin, 1870–1953) to evoke the forces of nature, such as the

currents of the wind. O'Keeffe's charcoals were also shaped by the ideas of abstract artist Wassily Kandinsky in his book *Concerning the Spiritual in Art* (1911). She later noted that 'it was some time before I really began to use the ideas [in *Concerning the Spiritual in Art*]. I didn't start until I was down in Carolina – alone – thinking things out for myself.' Kandinsky's work deepened her understanding of the power of abstract form and colour.

► FOCUS (1) ABSTRACT CHARCOALS, P.16

INTRODUCTION TO STIEGLITZ

In autumn 1915, O'Keeffe sent a group of her charcoals to a friend in New York, Anita Pollitzer, who showed them to Alfred Stieglitz (1864–1946). An internationally known photographer and the father figure of art photography in America, Stieglitz managed 291, the first modernist art gallery in the United States, in New York City. Opening in 1908, the gallery exhibited European avant-garde artists (including Picasso, Matisse and Brancusi), giving Americans their first exposure to such developments well before the famed Armory Show of 1913. Stieglitz also edited *Camera Work*, the premier modernist art and photography journal in America. He was therefore a highly influential figure in the art world, someone who had the power to help establish a successful career. Stieglitz was quite impressed with the charcoals that Politzer showed him. This elated O'Keeffe and led to the start of a prolific correspondence between them. Stieglitz later included her work in several exhibitions at his 291 gallery and, eventually, the two would marry.

4
Wassily Kandinsky (1866–1944)
Black Lines (Schwarze Linien), 1913
Oil on canvas
129.4 × 131.1 cm (51 × 51 ⅝ in)
Solomon R. Guggenheim Museum,
New York

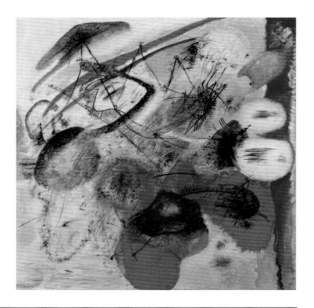

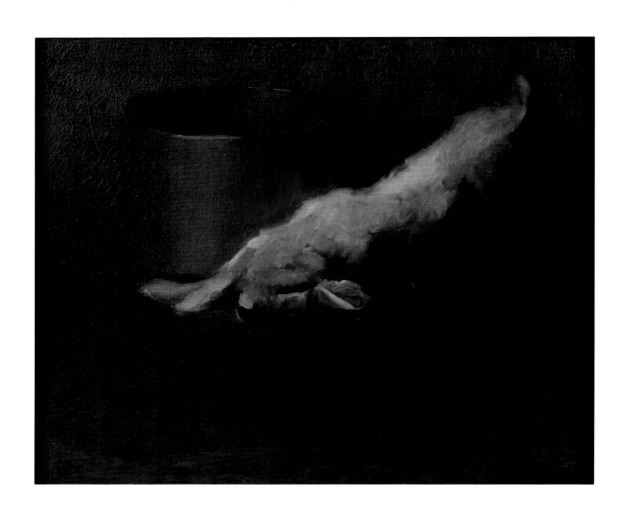

5
Untitled (Dead Rabbit and Copper Pot), 1908
Oil on canvas
48.3 × 59.7 cm (19 × 23 ½ in)
Art Students League of New York

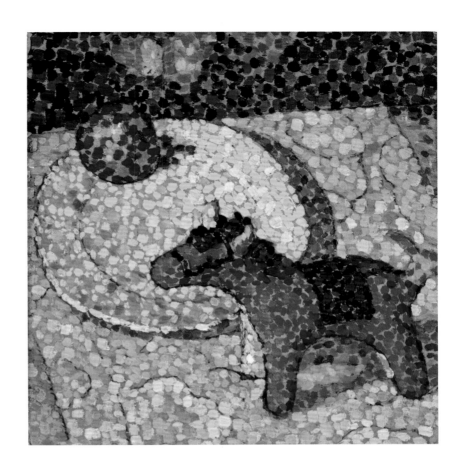

6
Untitled (Horse), 1914
Oil on cardboard
31.7 × 29.2 cm (12 ½ × 11 ½ in)
Georgia O'Keeffe Museum, Santa Fe

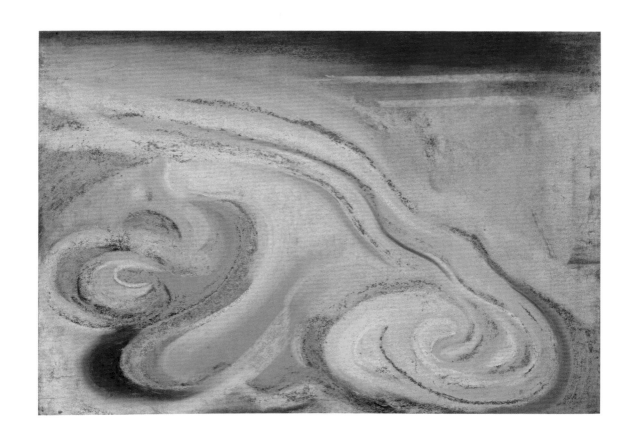

7
No. 32 – Special, 1915
Pastel on paper
36.8 × 50.8 cm (14 ½ × 20 in)
Smithsonian American Art Museum,
Washington, DC

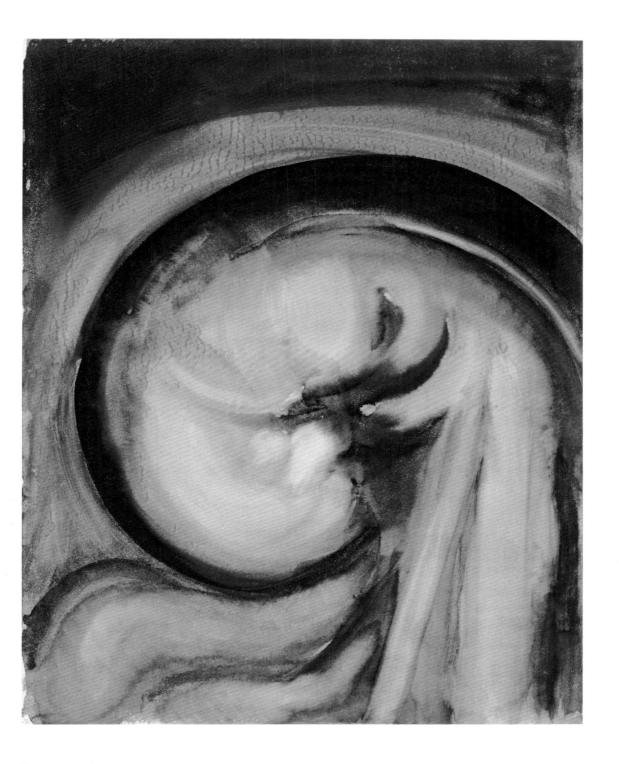

8
Blue II, 1916
Watercolour on paper
70.8 × 56.5 cm (27 ⅞ × 22 ¼ in)
Georgia O'Keeffe Museum, Santa Fe

FOCUS ①

ABSTRACT CHARCOALS

In *Concerning the Spiritual in Art* (1911), Wassily Kandinsky eloquently reprises the Symbolist idea that form can be an equivalent for feeling. O'Keeffe was exploring the same concept when she produced her charcoals, such as *Early No. 2* [10], wrestling with what could be expressed through abstract form alone. One of the strangest, and most ominous-looking, of her abstract charcoals is *Special No. 9* [11], which could represent the edge of a volcano or a hellish scene, evoking smoke and fire. The undulating rhythms were prompted by an intense headache, with throbbing pains. Charcoals such as this convinced O'Keeffe that line could be endowed with life, an idea she had initially discovered from the reproductions of Japanese and Chinese ink-brush paintings [9] that Dow and Bement had shown to their students.

Several of O'Keeffe's charcoals convey interiority, presaging her later depictions of flowers. *No. 8 – Special* [12], for example, could be seen (as it seems to have been interpreted at the time) as depicting a vagina or womb. Such images by O'Keeffe prompted one critic to write that they reveal 'the innermost unfolding of a girl's being, like the germinating of [a] flower'. Stieglitz said that 291 had 'never before seen Woman express herself so frankly on paper'. According to Stieglitz, 'Woman feels the world differently than Man feels it ... The Woman receives the World through her Womb ... Mind comes second.' Even before O'Keeffe became known for her paintings of flowers, people were already describing her work in highly gendered, indeed sexist, terms.

In some ways O'Keeffe's charcoals were a cul-de-sac, since they had little impact on her later output. Nonetheless, the charcoals do forecast her career-long love of organic shapes, close-up viewpoints and contours, as well as her penchant for exploring themes in a series. They also fore-shadow her striking abstract pictures from the 1920s [30, 31]. Moreover, and very importantly for her later career, the charcoals brought O'Keeffe's talent to the attention of Alfred Stieglitz.

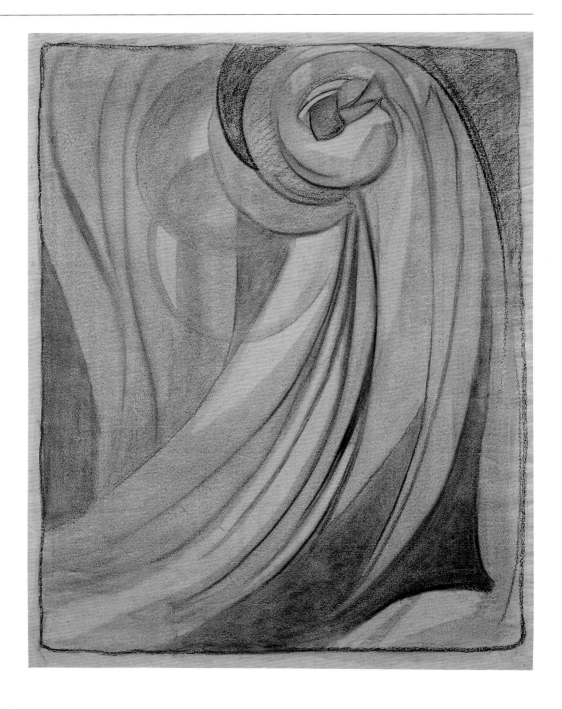

◄ 9
Hayashi Jikko (1778–1813)
Eels, early nineteenth century
Ink on paper
126.6 × 40 cm (50 × 16 in)
Tokyo National Museum

10
Early No. 2, 1915
Charcoal on paper
61 × 47 cm (24 × 18 ½ in)
The Menil Collection, Houston

11
Special No. 9, 1915
Charcoal on paper
63.5 × 48.6 cm (25 × 19 ⅛ in)
The Menil Collection, Houston

12
No. 8 – Special, 1916
Charcoal on paper
61.6 × 47.9 cm (24 ¼ × 18 ⅞ in)
Whitney Museum of American Art, New York

WEST TEXAS

In March 1916, O'Keeffe left her job in South Carolina and returned for one semester to Teachers College in New York City. She needed to take a methods course, which was required for a new position she had accepted as Head of the Art Department at the West Texas State Normal College in Canyon, Texas.

In early May, her mother died. By then O'Keeffe had become estranged from her father, whom she never saw again, but she remained close to several of her sisters. Later that month, Stieglitz hung ten of her works at his 291 gallery without her permission or knowledge. She subsequently noted, 'I was startled and shocked. For me the drawings were private and the idea of their being hung on the wall for the public to look at was just too much ... Stieglitz and I argued and though I didn't like it, I went away leaving the drawings on the wall.' Stieglitz was known for his stubbornness.

After spending the spring in New York City, O'Keeffe taught a summer class for her former instructor Alon Bement at the University of Virginia and then moved to her new teaching post in the West Texas town of Canyon, not far from her previous job in Amarillo. Living with her younger sister Claudia, she remained in that position for about a year. The surrounding landscape fired her imagination; she produced several oils, charcoals and contour drawings, along with about thirty watercolours. Conveying with assurance a sense of joyous exhilaration, these showcase O'Keeffe's gift for formal simplicity and graphic design. She also understood the distinctive potential of watercolour as a medium; the works possess a remarkable luminosity, freshness and immediacy.

SMOKING TRAINS

[16] One of O'Keeffe's Texas watercolours, *Train at Night in the Desert*, which sold the next year for $400, reduces the front of the engine to a simple yellow circle inside a black one. The scene is dominated by the gloriously colourful plume of smoke, its rounded forms echoed in the curving green train tracks that seem to glide on air. The black vertical forms at the top, where she let the watercolour paint pool on the paper, seem to be pouring down the sky. *Train at Night in the Desert* is a clear nod to Stieglitz's canonical photograph *The*
[13] *Hand of Man*. Stieglitz's composition, however, is a gritty urban image showing a distant train belching a towering column of smoke, whereas O'Keeffe's vision displays a more colourful scene.

O'Keeffe would have known Stieglitz's print from the journal *Camera Work*. Stieglitz presided over a small group of avant-garde artists and critics, and her

◄ O'Keeffe in Texas, 1918.

13
Alfred Stieglitz
(1864–1946)
The Hand of Man, 1902
Photogravure
24.1 × 31.8 cm
(9 ½ × 12 ½ in)
National Gallery of Art,
Washington, DC

relationship with him lent her opportunities that she would not otherwise have enjoyed. Through his gallery shows and writings, her art gained visibility and legitimacy. *Train at Night in the Desert*, which was one of three versions she produced, was the start of a long and fruitful artistic dialogue with Stieglitz, as the creativity of one continued to inspire the other.

PALO DURO CANYON

During her year in Canyon, Texas, O'Keeffe frequently visited the nearby Palo Duro Canyon, sometimes accompanied by her nineteen-year-old student Ted Reid, with whom she may have had an affair. The canyon, which forms a dramatic gash in the earth over 160 km (100 miles) long and 240 m (800 feet) deep in the midst of an expansive arid landscape, is dominated by horizontal bands of red sandstone cliffs and castle-like buttes.

O'Keeffe was captivated by the canyon and loved to hike in it. She described it as 'a place where few people went ... The weather seemed to go over it ... We saw the wind and snow blow across the slit in the plains as if the slit didn't exist.' Her provocative use of the word 'slit' tranforms the canyon into a mother earth figure. Throughout her career, O'Keeffe would anthropomorphize nature in her renditions of it. Her portrayals of the canyon, such as the oil painting *No. 21 – Special*, capture its rugged terrain and intense colours. [17] Here nature is shown as a magical escape from ordinary life, an idea that lies at the heart of much of her outlook.

The picture's eerie, simplified clouds suggest the paintings of the late nineteenth-century American artist Albert Pinkham Ryder as well as the land- [14] scapes of the Swiss painter Ferdinand Hodler (1853–1918). Yet, as with most of O'Keeffe's West Texas work, *No. 21 – Special* is very much her own. She

sometimes waited weeks after a visit to the canyon before painting it; this scene has clearly been refracted through the prisms of imagination and memory. Transmuted into a kind of huge glowing body, it is a fairytale image.

► FOCUS ② THE WEST TEXAS WATERCOLOURS, P.26

What makes the West Texas landscape so captivating is that often nothing obtrudes between the viewer and the distant horizon. It is an elemental place, dominated by the sky. Some of O'Keeffe's scenes show the firmament ablaze with gaudy sunsets, coloured by dry red soil blown into the air. The watercolour *Sunrise and Little Clouds No. II*, from 1916, is part of a tradition of *plein air* (that is, created 'in the open air') sketches extending back into the eighteenth century in Europe. The painting, one of the more naturalistic of this group, is reminiscent of the sunset views by nineteenth-century American Romantic landscape painters of the Hudson River School, especially Frederic Church (1826–1900) and Albert Bierstadt (1830–1902). Similar to these earlier painters, O'Keeffe depicted a sublime, pyrotechnical display. The cloud-filled sky feels luridly organic, like undulating tissue. Its stylized, light-filled clouds also recall stained glass, and the work's tripartite composition anticipates the later paintings of Mark Rothko (1903–1970).

[15]

[107]

14
Albert Pinkham Ryder (1847–1917)
Lord Ullin's Daughter, before 1907
Oil on canvas
51.2 × 45.8 cm (20 ½ × 18 ⅜ in)
Smithsonian American Art Museum,
Washington, DC

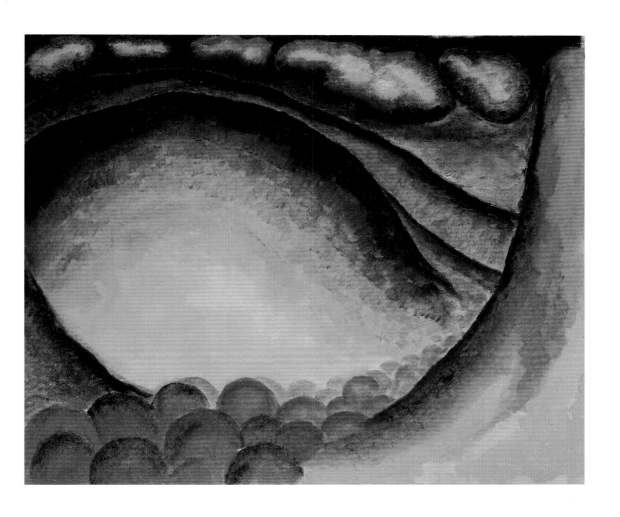

◄15
Sunrise and Little Clouds No. II, 1916
Watercolour on paper
22.5 × 30.5 cm (8 ⅞ × 12 in)
Georgia O'Keeffe Museum, Santa Fe

◄16
Train at Night in the Desert, 1916
Watercolour and graphite on paper
30.3 × 22.5 cm (11 ⅞ × 8 ⅞ in)
The Museum of Modern Art, New York

17
No. 21 – Special, 1916–7
Oil on board
34.3 × 41.3 cm (13 ½ × 16 ¼ in)
New Mexico Museum of Art, Santa Fe

O'Keeffe was not enamoured with Impressionism and rarely interested in depicting changes in light. For this reason, her Light Coming on the Plains [20, 21] series of sunrise views is distinctive. With their subtle gradations of tone, they capture the nascent, growing light of dawn. Although somewhat akin to Monet's earlier Haystacks series of 1890 and 1891, O'Keeffe's drawings are concerned less with the ephemeral effects of light than the essential, pared down forms of the landscape: a sunrise becomes a distilled decorative shape. The Light Coming on the Plains images meditatively fuse self and world. Limpid and spare, their combination of delicacy and boldness place them among her strongest pictures. With *Light Coming on the Plains No. 1*, she uses the bare paper to create bands of radiance that intensify the colours bracketing them. The series demonstrates O'Keeffe's fascination with the flat simplification of Japanese Ukiyo-e woodblock prints [18], but her watercolours are much more abstract, transforming the aesthetic of Japanese prints into an emblem of rhapsodic purity.

Evening Star No. III [19], which is one of a sequence of eight watercolours, is another of O'Keeffe's strongest Texas pictures. Employing cadmium red and Prussian blue and leaving large areas of the paper untouched, she has created an image that pulses with energy. The sky becomes a bejewelled river of light, the heavens made lyrical. This watercolour exploits the fluidity of the medium and exemplifies O'Keeffe's love of juxtaposing positive and negative forms. As she noted, 'The evening star would be high in the sunset sky when it was still broad daylight. That evening star fascinated me ... I had nothing but to walk into nowhere and the wide sunset space with the star.'

She frequently wrote that she wanted to capture how she 'felt' about the subjects she painted, and this work exudes an unrestrained sense of wonder. It depicts a cosmic meeting of earth and sky, with concentric circles of light above touching the darkening land below. O'Keeffe's watercolours are direct, elemental and luminous. One can only imagine what she might have gone on to accomplish in this medium had her future husband Stieglitz not discouraged her from pursuing it – possibly because of its unappealing association with amateur painting by genteel 'ladies'.

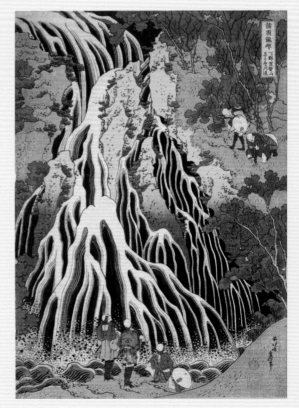

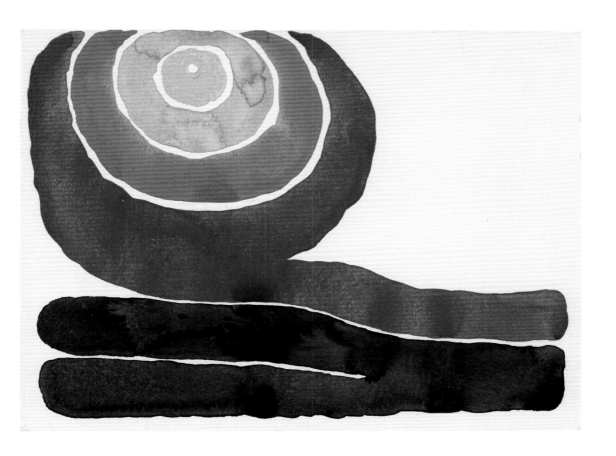

◄ 18
Katsushika Hokusai (1760–1849)
*Pilgrims at Kirifuri Waterfall on Mount
Kurokami in Shimotsuke Province, c.1831–2*
Colour woodcut
37.6 × 25.7 cm (14 ¹³⁄₁₆ × 10 ⅛ in)
Philadelphia Museum of Art

19
Evening Star No. III, 1917
Watercolour on paper
22.7 × 30.4 cm (8 ⅞ × 11 ⅞ in)
The Museum of Modern Art, New York

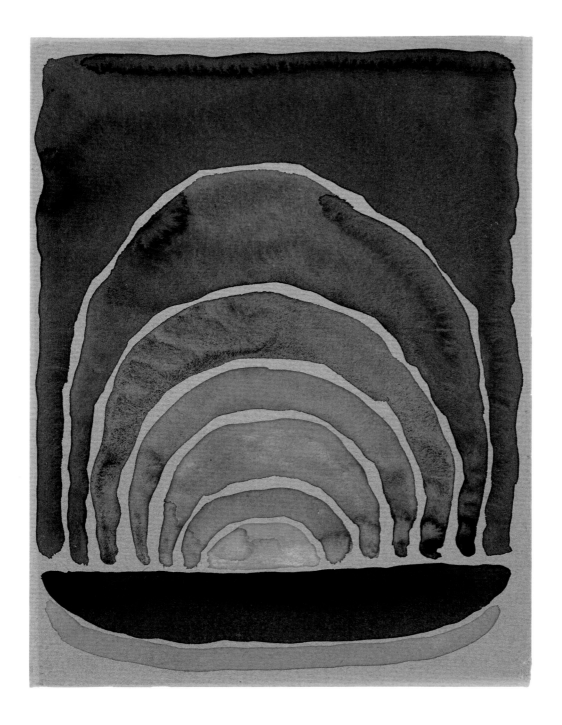

20
Light Coming on the Plains No. I, 1917
Watercolour on newsprint paper
30.1 × 22.6 cm (11 ⅞ × 8 ⅞ in)
Amon Carter Museum of American Art,
Fort Worth

21
Light Coming on the Plains No. II, 1917
Watercolour on newsprint paper
30 × 22.5 cm (11 ⅞ × 8 ⅞ in)
Amon Carter Museum of American Art,
Fort Worth

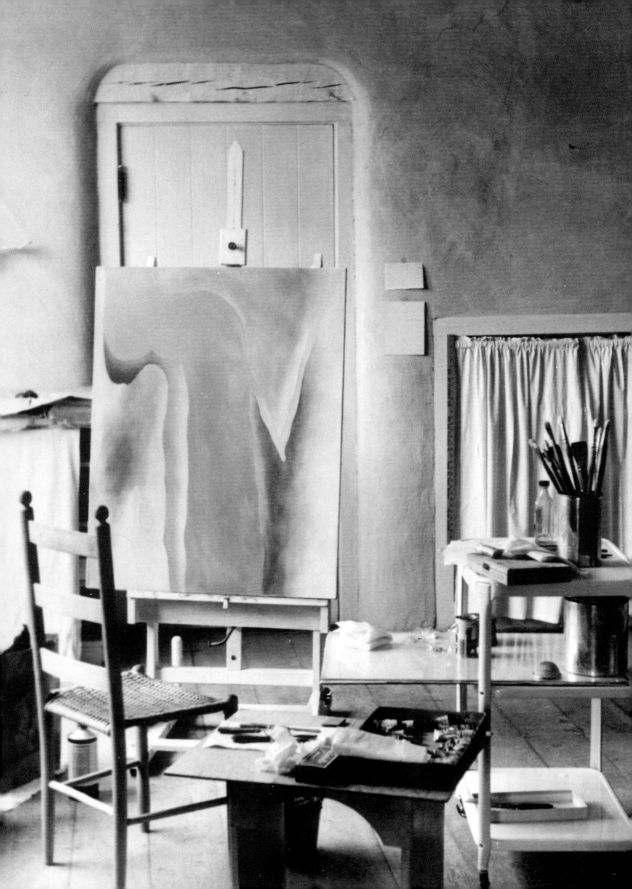

ABSTRACT PAINTINGS

In May 1917 O'Keeffe travelled by train to New York to see her debut solo exhibition, at the 291 gallery. As she did not arrive until after the show had closed, Stieglitz re-hung it for her. Already besotted with O'Keeffe, Stieglitz made a set of photographs of her. O'Keeffe herself reacted similarly to that visit, becoming infatuated with Stieglitz. After returning to Texas, in February 1918, O'Keeffe contracted the Spanish influenza – the disease which would kill millions around the world. Taking a leave of absence from her job in Canyon, she moved to Waring, in the far eastern part of Texas, where she continued to produce decorative watercolours. She did not get along well with her conservative colleagues in Canyon (for instance, she was a pacifist during World War I), so when she learned in May 1918 that Stieglitz wanted her to move to New York, she jumped at the opportunity, leaving her teaching job forever.

JOINING STIEGLITZ IN NEW YORK

Arriving in Manhattan on 10 June, she and Stieglitz almost immediately began a passionate romance. Always drawn to younger women, Stieglitz was fifty-four years old in 1918, twenty-four years older than O'Keeffe. He separated from his wife Emmy, with whom he had a daughter, Kitty. Because the divorce took several years to settle, Stieglitz and O'Keeffe would not marry until 1924. In August 1918 they visited Oaklawn, at Lake George, upstate New York. Surrounded by forested mountains and within sight of the water, it was where the extended Stieglitz clan met for holidays and was dominated by Alfred's imperious mother Hedwig until her death in November 1922.

Despite her relocation, O'Keeffe continued to think about her previous experiences in Texas and made two additional West Texas pictures in 1919, both highly abstracted scenes in oil. These dramatic paintings are quite [24-5] different in tone from the watercolours. *Red and Orange Streak* and *Series I – From the Plains* are modernist versions of the sublime. The horizontal red band in *Red and Orange Streak* resembles a high desert sunset, while the dark forms above recall a storm. The vertical curving band of yellow-orange and the soft green passages to the right evoke lightning, rain and wind. Directing the viewer's eye towards the heavens, it could almost suggest Zeus hurling a lightning bolt. This composition indicates that the American West had already cast [26] a lasting spell upon her. While *Series I – No. 4* exemplifies O'Keeffe's fascination during this period with wave-like folded motifs and her frequent juxtaposition [27] of complementary colours, *Abstraction* betrays a clear influence from the

◄ Inside O'Keeffe's studio at Ghost Ranch, New Mexico.

organic cubist forms of Francis Picabia (1879–1953). Stieglitz owned several abstracts by Picabia, a celebrated French painter whose work was exhibited at the famous Armory Show of modern art in New York in 1913.

SYNAESTHESIA

According to O'Keeffe, *Red and Orange Streak* was inspired by her Texas memories of 'the cattle in the pens lowing for the calves day and night … It was loud and raw under the stars in that wide empty country'. It exemplifies her interest in synaesthesia, the use of form and colour to evoke sound. She had first discovered the concept at Teachers College in 1914–15, when she was walking past one of Bement's classes. Hearing music coming from the room, she 'opened the door and went in. A low-toned record was being played and the students were asked to make a drawing from what they heard. So I sat down and made a drawing, too. Then he played a very different kind of record – a sort of high soprano piece – for another quick drawing. This gave me an idea that I was very interested to follow later – the idea that music could be translated into something for the eye.'

Interest in synaesthesia went back to the 'colour organs' of the eighteenth century, mechanical devices that attempted to represent sound visually. Since the 1870s numerous painters – from James McNeill Whistler (1834–1903) to Kandinsky – had been intrigued by this idea. Some of O'Keeffe's contemporaries considered music a higher form of art, divorced from ordinary life and embodying expression in its purest form.

22
Charles Burchfield (1893–1967)
The Insect Chorus, 1917
Watercolour, ink, graphite and crayon on paper
50.8 × 38.1 cm (20 × 15 ⅞ in)
Munson-Williams-Proctor Arts Institute, Museum of Art, New York

23
Arthur Dove (1880–1946)
George Gershwin – Rhapsody in Blue, Part I, 1927
Oil and metallic paint with clock spring on aluminium support
30 × 24.8 cm (11 ¾ × 9 ¾ in)
Private collection

By the early twentieth century, the concept of synaesthesia had become widely known in the American art world, and the nation's painters and photographers often experimented with it. For instance, simultaneously with O'Keeffe's Texas watercolours, the visionary artist Charles Burchfield was painting a series of brilliant evocations of the sounds and rhythms of nature in the same medium. *The Insect Chorus*, whose vibrant stylized lines betray
[22]
debts to Art Nouveau and Chinese scroll paintings, epitomizes Burchfield's pantheistic view of nature. O'Keeffe may not have been aware of Burchfield but would have known the synaesthetic paintings of Stieglitz's friend Arthur Dove, although she would never have produced an image as busy
[23]
as Dove's *George Gershwin – Rhapsody in Blue, Part I*. Erupting with boisterous energy and improvisatory freedom, it typifies Dove's love of unorthodox materials in its use of metallic paint and an attached clock spring.

► FOCUS ③ OTHERWORLDLY MUSIC, P.38

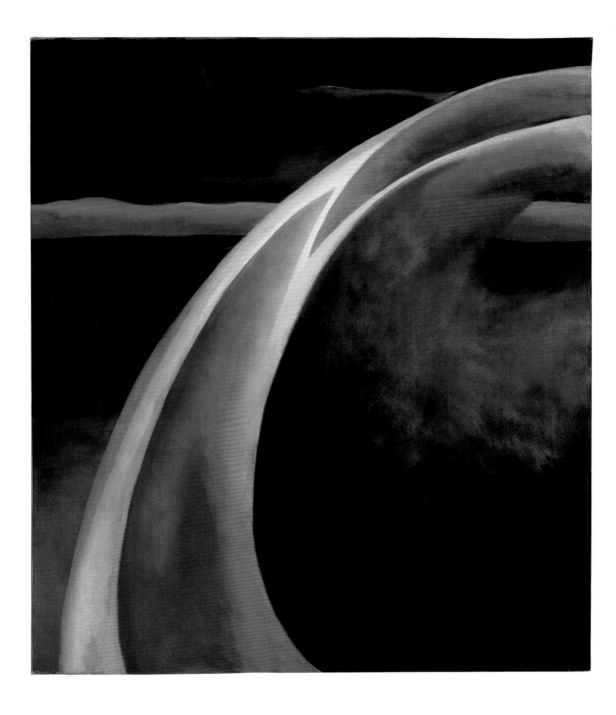

24
Red and Orange Streak, 1919
Oil on canvas
68.6 × 58.4 cm (27 × 23 in)
Philadelphia Museum of Art

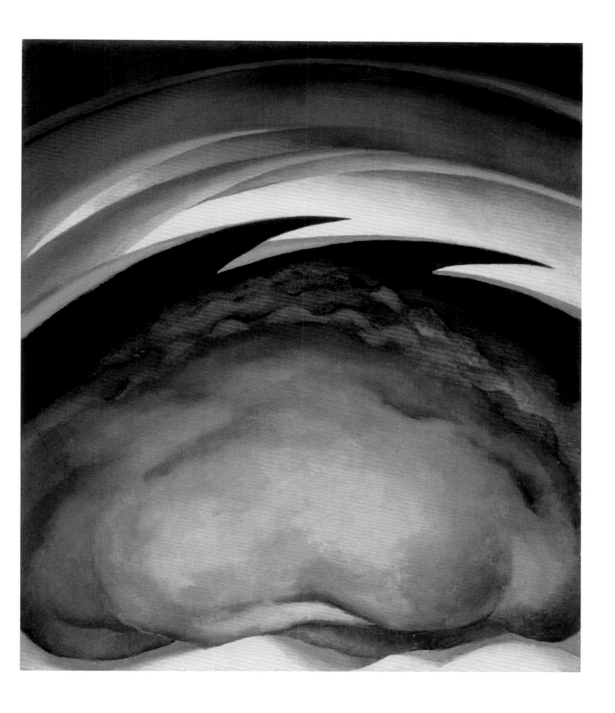

25
Series 1 – From the Plains, 1919
Oil on canvas
68.6 × 58.4 cm (27 × 23 in)
Georgia O'Keeffe Musem, Santa Fe

Whereas her West Texas watercolours are principally about light, an ideal subject for the medium, O'Keeffe's oils convey the physicality and power of the landscape – in this case a massive, rain-laden cloud that fills the sky. The jarring saw blade shapes above the cloud suggest a titanic battle between forces of nature, a feeling that is antithetical to her delicate watercolour paintings.

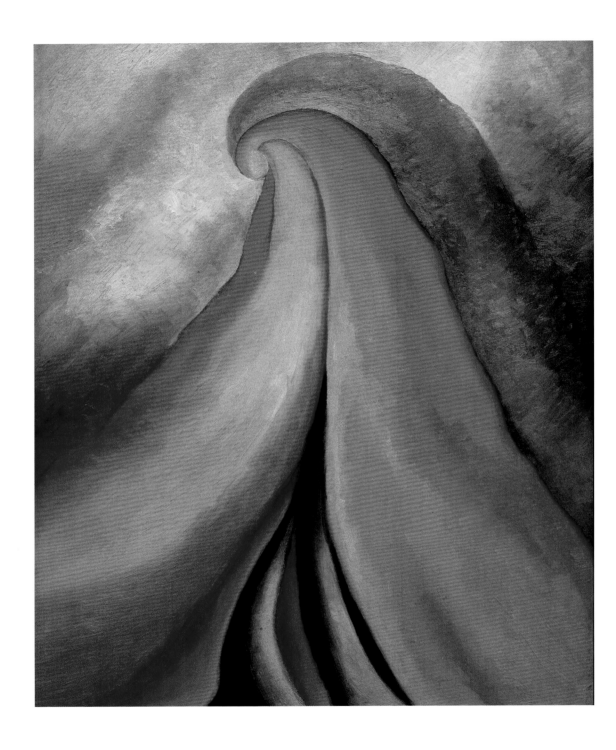

26
Series 1 – No. 4, 1918
Oil on canvas
50.8 × 40.6 cm (20 × 16 in)
Städtische Galerie im Lenbachhaus,
Munich

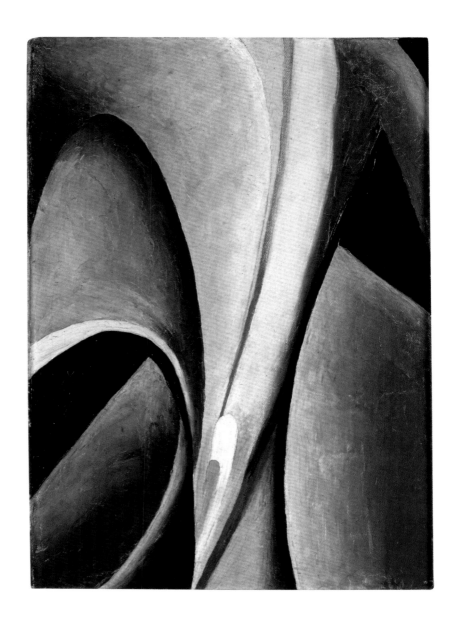

27
Abstraction, 1919
Oil on canvas
25.7 × 17.9 cm (10 1/8 × 7 1/16 in)
Newark Museum, New Jersey

FOCUS ③

OTHERWORLDLY MUSIC

O'Keeffe created the majority of her completely abstract paintings between 1918 and 1930. In the context of the early twentieth century, works such as *Music, Pink and Blue No. 2* [29] are distinctive for their organic and corporeal feeling, as if she had enlarged a blood vessel. Enclosed spaces are also a recurring motif. This image could be read as erotically tinged, with its voluptuous pink, orange and red folds and its vulva-like opening. The painting's deep blue oval is a nod to Kandinsky, who wrote in *Concerning the Spiritual in Art* that 'blue is the typical heavenly colour'. *Music, Pink and Blue No. 2* depicts a mysterious, sensuous 'place', embodying O'Keeffe's belief that art should be insulated from ordinary life and that painters should plunge into their imagination. A sense of the otherworldly is also conveyed by *Blue and Green Music* [30], a fugue of undulating patterns. The blue-black diagonal lines, which seem at once flat and deep, present a stark counterpoint to the organic shapes, which resemble flames or, at the lower left, a wave-marked beach.

Line and Curve [31] is one of several white and grey abstracts that O'Keeffe produced between 1918 and 1930. Spare and ghostly, with delicately modulated tones, *Line and Curve* reaches back to the paintings of Whistler but owes much more to early Cubism. Like the paintings of Picasso [1] and Braque, *Line and Curve* is monochromatic and depicts a shallow space, but, in contrast, purges any sign of representation. This composition appears to be unrelated to the two major contemporary European movements employing geometric abstraction, De Stijl and Constructivism, whose artists, including Piet Mondrian [28], evolved paintings dominated by squares and ruler-straight lines.

In viewing O'Keeffe's work during this period, one is struck by how she oscillated between abstraction and realism. After a period of producing many daring abstracts, from 1915 to 1919, she often embraced still lifes of fruit and flowers that embody tradition as demonstrations of craft and illusionism. This is another instance of her not accepting the orthodoxy of high modernism.

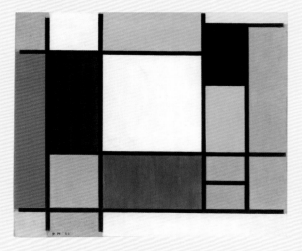

28
Piet Mondrian (1872–1944)
Composition with Yellow, Red, Black, Blue, and Grey, 1920
Oil on canvas
51.5 × 60 cm
(20 ¼ × 23 ⅝ in)
Stedelijk Museum, Amsterdam

29 ►
Music, Pink and Blue No. 2, 1918
Oil on canvas
88.9 × 76 cm (35 × 29 ¹⁵/₁₆ in)
Whitney Museum of American Art, New York

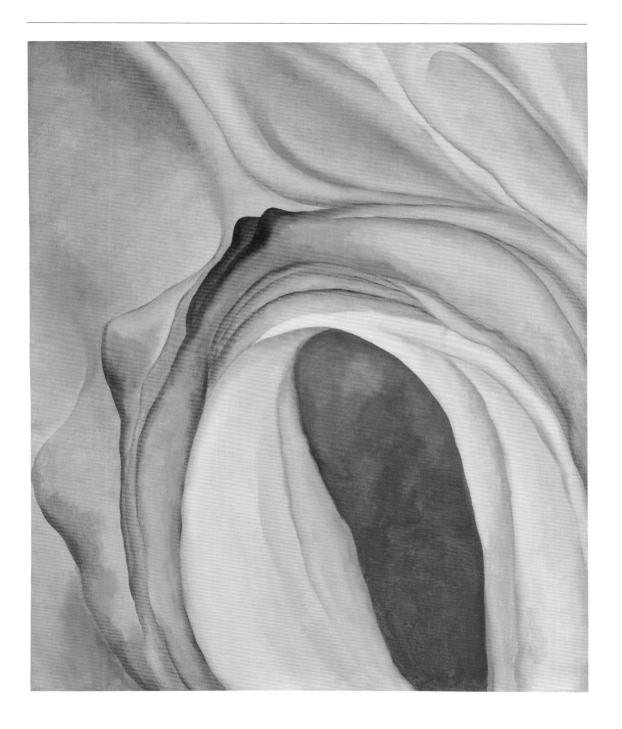

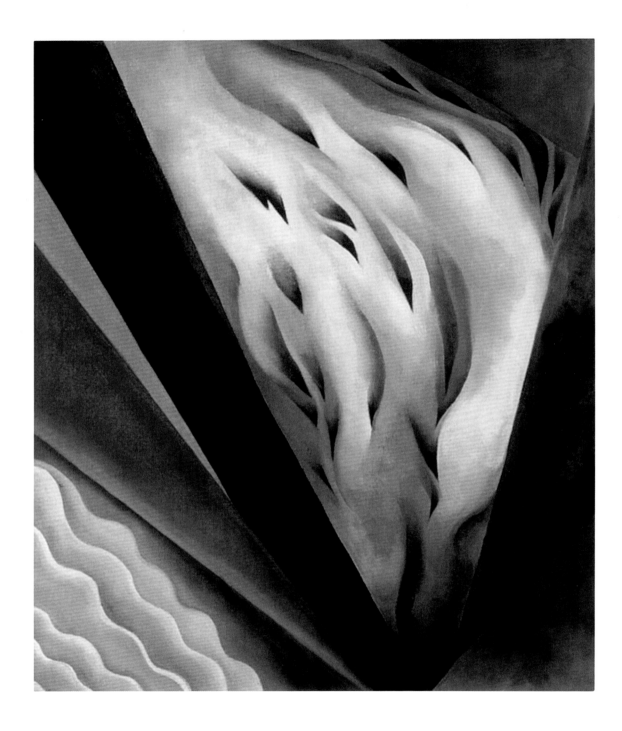

30
Blue and Green Music, 1919–21
Oil on canvas
58.4 × 48.3 cm (23 × 18 in)
The Art Institute of Chicago

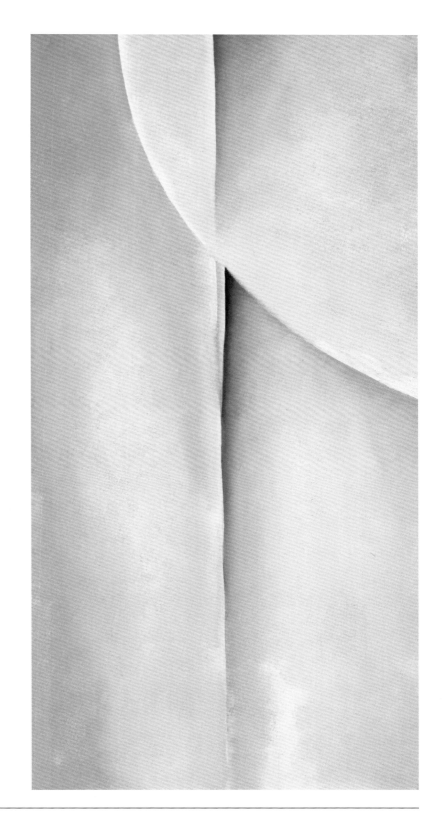

31
Line and Curve, 1927
Oil on canvas
81.2 × 41.2 cm (31 ¹⁵⁄₁₆ × 16 ¼ in)
National Gallery of Art,
Washington, DC

THE FLOWERS

[38]

O'Keeffe will forever be known for her flower paintings. With icons such as *Petunia No. 2* she found her artistic voice, and the flower paintings established her as one of the major figures in the American art world. She took a genre and made it her own, turning something conventional and tired into something vital and original. Nothing captured O'Keeffe's imagination more than flowers, and she returned to the theme for nearly four decades.

Flowers provided everything she liked in their decorative forms with rounded shapes and crisp edges. She was an avid gardener and a frequent patron of florist shops in New York, which may explain how she could paint nearly thirty types, from carnations and roses to larkspurs, hollyhocks and trumpet flowers.

As a child she had produced depictions of flowers but first returned to the subject as an adult in 1919 with a series of watercolour and oil renderings of red cannas. Most of these early flowers include the stem and leaves. By 1924 though she was focusing mainly on the blossoms themselves. This shift seems to have been prompted by her wish to encourage people to look at flowers up close. She later commented that 'Everyone has many associations with a flower. You put out your hand to touch it, or lean forward to smell it, or maybe touch it with your lips almost without thinking, to give it to someone to please them. But one rarely takes the time to really see a flower. I have painted what each flower is to me and I have painted it big enough so that others would see what I see.' She also noted that her images would even make 'busy New Yorkers' attend closely to flowers.

INTIMACY AND MONUMENTALITY

Her flowers derive their force from their fusion of intimacy and monumentality; they imply that the viewer has suddenly become quite small, almost ant-like. They are majestic worlds unto themselves, intended, above all, to keep the wider world at bay. This is a secular version of the flower as *hortus conclusus*, an enclosed garden that, in the Middle Ages, symbolized the purity of the Virgin Mary. O'Keeffe saw flowers as a refuge, and she also considered them a catalyst for the imagination and a means to awaken the senses.

[39]

[32]

In deciding to focus on the flower itself, magnifying its scale, O'Keeffe may have drawn inspiration from botanical prints. Works such as *Black Pansy & Forget Me Nots*, from 1926, hark back to illustrations like William Sharp's stunning chromolithograph of a waterlily, *Complete Bloom*. *Black Pansy & Forget Me Nots* also brings to mind Victorian pressed flowers. Yet, unlike

◄ O'Keeffe wearing a brooch that was a gift from the sculptor Alexander Calder, 1950.

32
William Sharp (1803–1875)
Complete Bloom, 1854
Chromolithograph
53.3 × 68.6 cm (21 × 27 in)
Amon Carter Museum of
American Art, Fort Worth

those, O'Keeffe's depictions of flowers are not botanically precise in their details. She was never trapped by the empirical, and her treatment of flowers always assert the power of the imagination. Nature is transformed, simplified and enlarged.

O'Keeffe's opulent *Oriental Poppies* are cut from the same cloth as *Sunflowers* by Vincent van Gogh. Both painters created paeans to nature that exalt its splendours. Their pictures encourage the viewer to feel a rush of astonishment. They would have admired the eminent nineteenth-century British critic John Ruskin's comment that 'I have in my hand a small red poppy ... like a burning coal fallen from Heaven's altars'. Van Gogh and O'Keeffe alike embraced a Symbolist belief that artists could employ nature to project inner feelings. Van Gogh's pantheistic renderings of reality are infused with life, owing to their wiry lines and vigorous brushstrokes. Set against a blue background, his sunflowers suggest hot suns in the firmament. O'Keeffe also shared with Van Gogh a love of Japanese woodblock prints, with their flattened decorative patterns and emphatic contour lines. As she observed, 'objective painting is not good painting unless it is good in the abstract sense.' [41] [33]

Many modernists – including Henri Matisse (1869–1954), Marsden Hartley (1877–1943), Émil Nolde (1867–1956) and Charles Demuth (1883–1935) – painted flowers. But O'Keeffe's decision to magnify the individual blossoms set her apart from other painters. In this, as the art historian Barbara Buhler Lynes and others have shown, O'Keeffe was indebted to the aesthetics of modernist photography. In the 1920s numerous American and European photographers depicted a range of objects, from flowers to machines, from a close perspective. For example, the American Imogen Cunningham (1883–1976) produced a series of monumentalizing renderings of magnolia blossoms. O'Keeffe was first introduced to the idea of magnifying subject matter by Paul Strand (1890–1976). Stieglitz, who thought Strand a brilliant innovator, devoted the last two issues of his journal *Camera Work*, in 1916 and 1917,

to Strand's work. O'Keeffe and Strand were friends, and she knew his close-up views of cameras, automobile wheels and bowls. Although O'Keeffe's images of flowers were influenced by photography, she never tried to make her paintings appear photographic in their details, while of course in that era virtually all art photography was black and white.

COLOURIST AND GRAPHIC ARTIST

At first glance, many of O'Keeffe's flower paintings may seem repetitive and formulaic. Yet, studied as a group, it becomes clear that their configurations, colours and compositions vary widely. As the gorgeous *Oriental Poppies* attests, flower subjects allowed her gifts as a colourist to shine. Highly disciplined as a painter, she employed a narrow range of colours in each work, striving to

produce extremely cohesive designs. For example, her *White Rose with Larkspur No. II* comprises almost entirely shades of white, blue and purple, with some green and yellow. The purple larkspur petals – unnaturally big over the relatively small but full-blown rose – seem to meld into the blue-white background, so that there is little distinction between figure and ground. The strange otherworldly ambience appears at once dense and infused with light. The ethereal delicacy of these flowers contrasts starkly with the insistent corporeality of those in *Oriental Poppies*, which are deliberately squeezed into the frame.

Yellow Hickory Leaves with Daisy further confirms O'Keeffe's versatility as both a colourist and draftsman. Its carefully balanced composition embodies order and control. The leaves, painted with a bright 'Naples yellow' pigment, fill most of the canvas with a flat symmetrical pattern that is enlivened by their ragged edges, a hint of decay that is rare in O'Keeffe's repertoire. The cropped leaves once more reveal that she availed herself of the conventions of modernist photography. With the small white daisy as its focal point, the picture might bring to mind an exotic headdress.

33
Vincent van Gogh (1853–1890)
Sunflowers, 1887
Oil on canvas
43.2 × 61 cm (17 × 24 in)
The Metropolitan Museum of Art,
New York

JACK-IN-THE-PULPIT SERIES

Inspired by the Jack-in-the-pulpit flowers she saw around the Lake George property, O'Keeffe produced one of her most famous pictorial series in 1930. As she noted: 'In the woods near two large spring houses, wild Jack-in-the-pulpits grew ... I did a set of six paintings of them. The first painting was very realistic. The last one had only the Jack from the flower.'

With lush green leaves swirling around in *Jack-in-the-Pulpit No. II*, this [44] painting includes more of a sense of context than most of O'Keeffe's flowers. The regal-looking flower or spathe (the 'pulpit') recalls Tiffany's celebrated Jack-in-the-pulpit vases from the turn of the century. The flower's curving white lines prefigure O'Keeffe's later aerial views of rivers.

Her highly abstract *Jack-in-the-Pulpit No. VI* represents only the plant's [45] vertical spadix or 'jack'. Mysterious and unknowable, its distilled form appears primordial, and the painting evokes the beginning of life, like a sperm searching for an egg. It also echoes the phallic forms of the skyscrapers in O'Keeffe's contemporary vistas of New York.

THE CALLA LILIES

By the late 1920s, O'Keeffe was caricatured as 'The Lady of the Lilies' for her many renderings of calla lilies. Numerous early twentieth-century American painters and photographers, including Joseph Stella (1877–1946), Charles Demuth, Edward Weston (1886–1958) and Marsden Hartley, also pictured calla lilies. O'Keeffe noted, in 1923, that 'I had seen Hartley's calla lilies, and thought I would try one to see if I could understand what it was all about.' Although calla lilies were associated with purity and feminine beauty, Hartley emphasized their phallic appearance.

O'Keeffe did the same, emphasizing the plant's yellow spadixes, which, in works like *Two Calla Lilies on Pink*, seem to erupt from the vaginal-looking [43] flower. Some saw her portrayals of calla lilies as lurid depictions of arousal.

MODERNIST EROTICISM

To understand O'Keeffe's motivations for producing erotically charged depictions of flowers, it is essential to place them in the larger context of modernism. Since the mid-nineteenth century, modernist artists, poets and novelists had commonly included forthright eroticism in their work. Born out of the Parisian demi-monde – with its cabarets, absinthe and courtesans – modernism first took the form of a bohemian subculture that prized shocking the bourgeoisie. Artists like Édouard Manet (1832–1883) relished defying mainstream moral sensibilities. That same wish to mock commonly held sexual mores continued into the twentieth century, with artists such as Egon Schiele (1890–1918), Picasso, Salvador Dalí (1904–1989) and Marcel Duchamp (1887–1968).

34
Paul Strand (1890–1976)
Akeley Motion Picture Camera, 1923
Gelatin silver print
24.1 × 19.2 cm (9 ½ × 7 %₆ in)
Metropolitan Museum of Art,
New York

Stieglitz and his circle belonged to that tradition – using themes of sexuality in their art as a declaration of being avant-garde. As the art historian Marcia Brennan has shown, Stieglitz was guided by the writings of Sigmund Freud and other psychologists who studied sexuality. Stieglitz read virtually all of Freud's books, as well as Havelock Ellis's six-volume *Studies in the Psychology of Sex,* which argues that art is driven by sexual energy. Thus, for Stieglitz, sex was a liberating source of creativity. O'Keeffe may or may not have thought of Freud when she painted her flowers, but the psychologist's writings were a cultural touchstone at the time, with his ideas widely known in a simplified fashion.

The Stieglitz circle's reverence for the writings of Walt Whitman, Charles Baudelaire and D. H. Lawrence – all of whom celebrated the libidinal and often linked it to nature and the outdoors – spurred their interest in amatory affairs. O'Keeffe herself admired the sexually explicit novels of Lawrence (*Lady Chatterley's Lover* was officially banned in America until 1959, although copies were obtainable). The sexual implications of O'Keeffe's flower paintings, along with the critical responses to them, thus participated in a larger current of modernist thought. Stieglitz, Hartley, Demuth, Gaston Lachaise (1882–1935) and Edward Weston were only some of the many contemporary American modernists who shared O'Keeffe's interest in exploring eros in their art.

FEMALE SEXUALITY

Although allusions to the erotic were common among artists of O'Keeffe's generation, critics nonetheless treated her work differently. Above all, they were determined to see her paintings as quintessentially feminine. For example, one critic stated that O'Keeffe 'gives the world as it is known to

woman ...', and Stieglitz similarly described her work as 'the unconscious expression of woman in every touch'. O'Keeffe herself helped promote this view when she said, 'I feel there is something unexplored about women that only a woman can explore.' In writing about her work, observers frequently mixed this characterization of inherent feminine otherness with female sexual longing and pleasure. They saw in works like *Black Iris* vaginas, labia-like folds and wombs.

[48]

O'Keeffe's flowers were also seen as autobiographical. For instance, the painter Marsden Hartley, who was a close friend, wrote that her paintings are 'probably as living and shameless private documents as exist ... By shamelessness, I mean unqualified nakedness of statement'. Likewise, the social critic Lewis Mumford wrote that O'Keeffe had 'found a language for experiences that are otherwise too intimate to be shared'. He also stated that her work was 'one long, loud blast of sex, sex in youth, sex in adolescence, sex in maturity ... sex bulging, sex tumescent, sex deflated'. Comments such as these should be understood against the backdrop of the 'roaring 20s', when Victorian notions of femininity began to develop an aura of unhealthy prudery. Some New York psychiatrists in the 1920s actually encouraged their female patients to visit O'Keeffe exhibitions in order to purge their sexual inhibitions.

William Carlos Williams's poem 'Queen-Anne's Lace', which was first published in 1921, helps explain the sexualized readings of O'Keeffe's flowers. The poem reads in part:

> Each flower is a hand's span
> of her whiteness. Wherever
> his hand has lain there is
> a tiny purple blemish. Each part
> is a blossom under his touch
> to which the fibres of her being
> stem one by one, each to its end,
> until the whole field is a
> white desire ...

Although Williams's poem employs the traditional association of women with nature, he refashioned it by presenting the poet as a god-like creative agency whose sensual touch transmutes the field of flowers into an aroused woman. Stieglitz used a similar concept to promote O'Keeffe's flowers, claiming they were the result of his own sexual prowess.

Starting in 1917 and continuing for the next two decades, Stieglitz made a famous series of about three hundred and fifty photographs of O'Keeffe, many of which show her in the nude. Most of those are cropped images that turn her body into an object of desire and a collection of abstract shapes. Stieglitz's photographs of her are highly self-conscious performances,

[35]

suggesting that she played a major role in shaping them. First shown in 1921, the photographs implicitly present O'Keeffe as Stieglitz's lusty muse. They reinforced the view that she was uninhibited and encouraged critics to see her flower paintings as reflections of her own carnal experiences. O'Keeffe decried such readings of her flowers, saying: 'When people read erotic symbols into my paintings, they're really talking about their own affairs.'

► FOCUS (4) THE QUESTION OF GENDER, P.60

[36-7]

It now seems abundantly clear that, in spite of her vehement denials, O'Keeffe meant some of her paintings (not just the flowers) to look vaginal. Works such as *Abstraction Seaweed and Water – Maine* and *Flower Abstraction* overtly allude to female genitalia. O'Keeffe's aim was to distinguish herself from her contemporary male artists by producing paintings that would seem both audaciously sexual and innately feminine. Moreover, the feminist writer Lisa L. Moore has argued that O'Keeffe's flowers should be seen as part of a lesbian tradition extending back to the eighteenth century, since some evidence suggests that O'Keeffe had several brief sexual affairs with women. According to Moore, these included Rebecca Strand (wife of Paul Strand), in 1929, when the two spent five months together in Taos, New Mexico, along with Mabel Dodge Luhan, that same summer in Taos. O'Keeffe may have also had an affair with Maria Chabot, who oversaw the renovation of O'Keeffe's Abiquiu hacienda between 1945 and 1949.

35
Alfred Stieglitz (1864–1946)
*Georgia O'Keeffe: A Portrait –
Torso*, 1918
Palladium print
24.1 × 18.9 cm (9 ½ × 7 ½ in)
National Gallery of Art,
Washington, DC

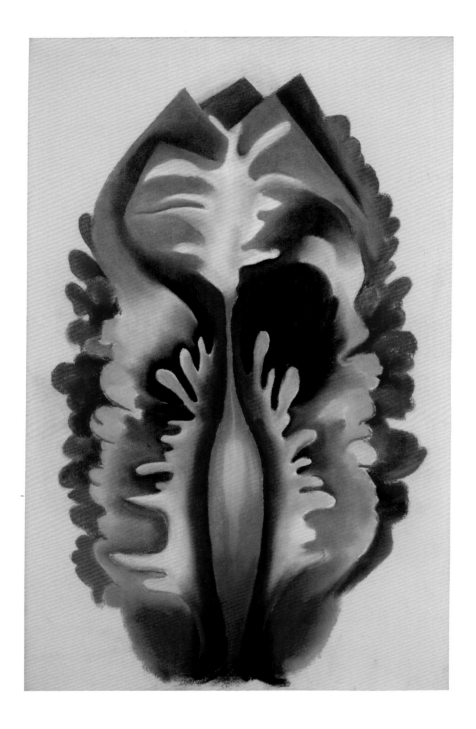

36
Abstraction Seaweed and Water –
Maine, 1920
Pastel on paper
72.4 × 45.1 cm (28 ⅛ × 17 ¾ in)
Georgia O'Keeffe Museum, Santa Fe

37 ►
Flower Abstraction, 1924
Oil on canvas
121.9 × 76.2 cm (48 × 30 in)
Whitney Museum of American Art,
New York

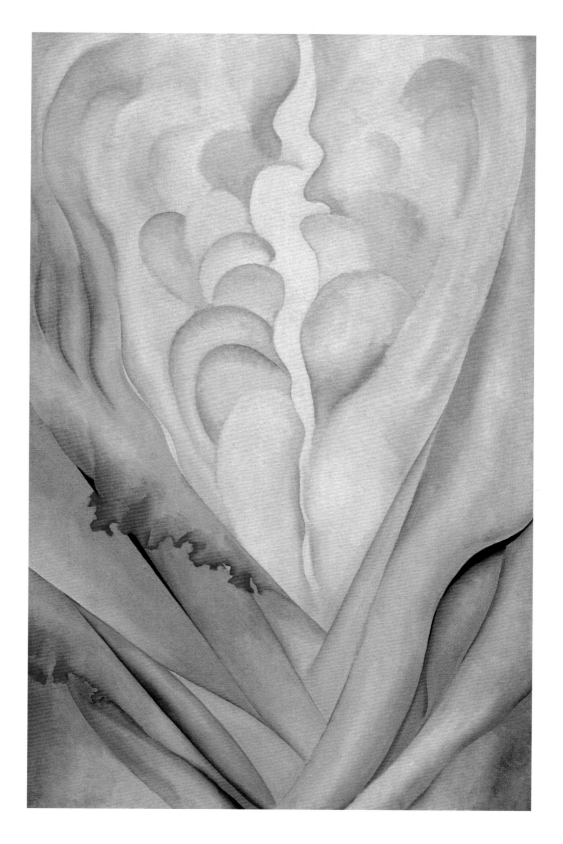

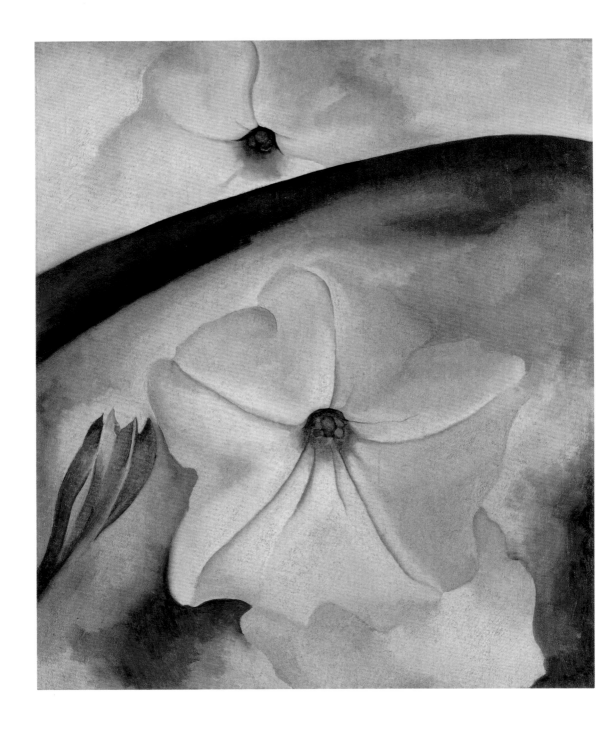

38
Petunia No. 2, 1924
Oil on canvas
91.4 × 76.2 cm (36 × 30 in)
Georgia O'Keeffe Museum, Santa Fe

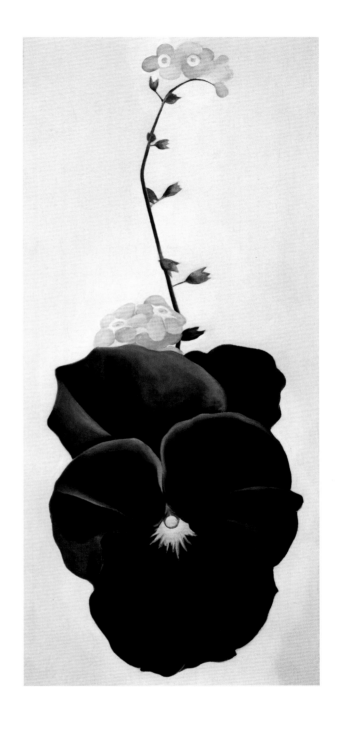

39
Black Pansy & Forget Me Nots, 1926
Oil on canvas
68.9 × 31.1 cm (27 ⅛ × 12 ¼ in)
Brooklyn Museum, New York

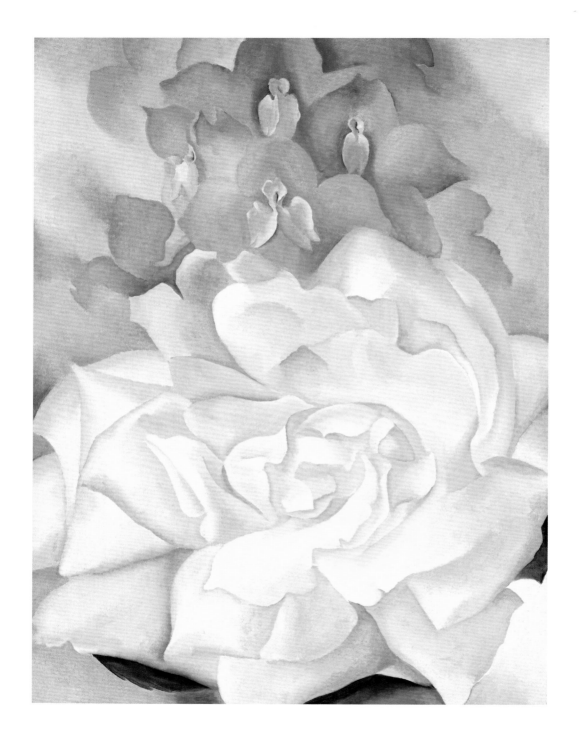

40
White Rose with Larkspur No. 2, 1927
Oil on canvas
101.6 × 76.2 cm (40 × 30 in)
Museum of Fine Arts, Boston

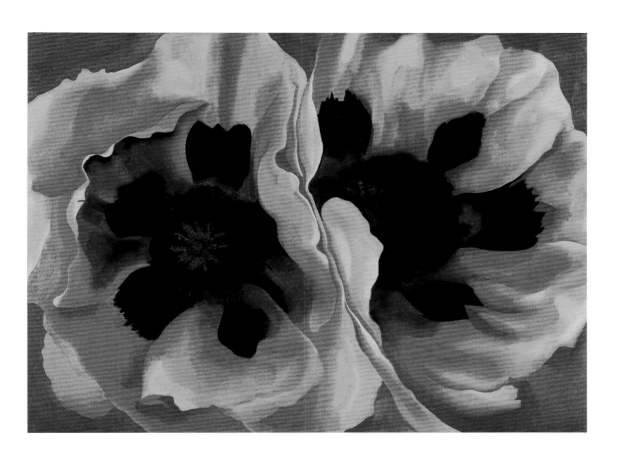

41
Oriental Poppies, 1927
Oil on canvas
76.2 × 101.6 cm (30 × 40 in)
Weisman Art Museum, University
of Minnesota, Minneapolis

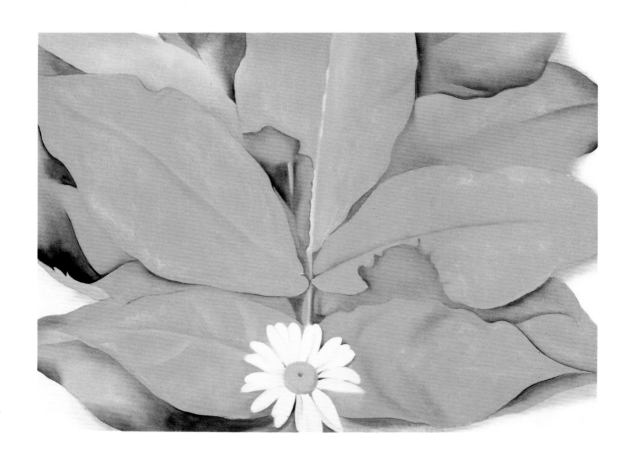

42
Yellow Hickory Leaves with Daisy, 1928
Oil on canvas
76.5 × 101.6 cm (30 × 40 in)
The Art Institute of Chicago

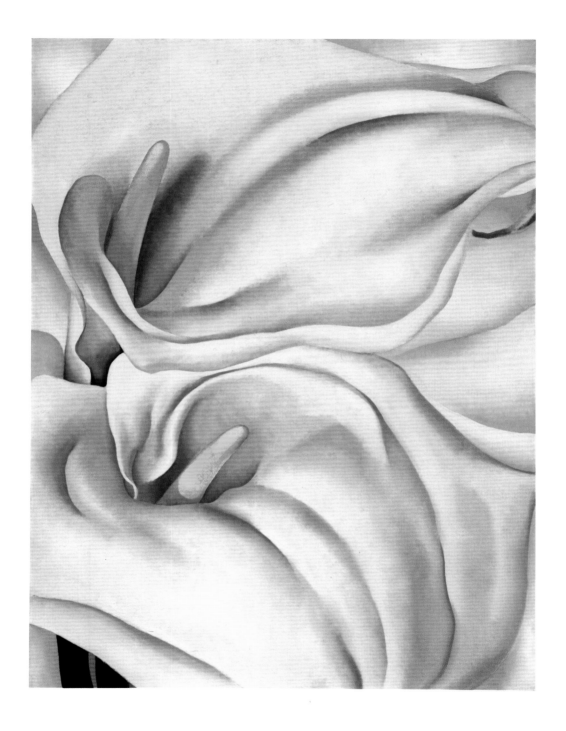

43
Two Calla Lilies on Pink, 1928
Oil on canvas
101.6 × 76.2 cm (40 × 30 in)
Philadelphia Museum of Art

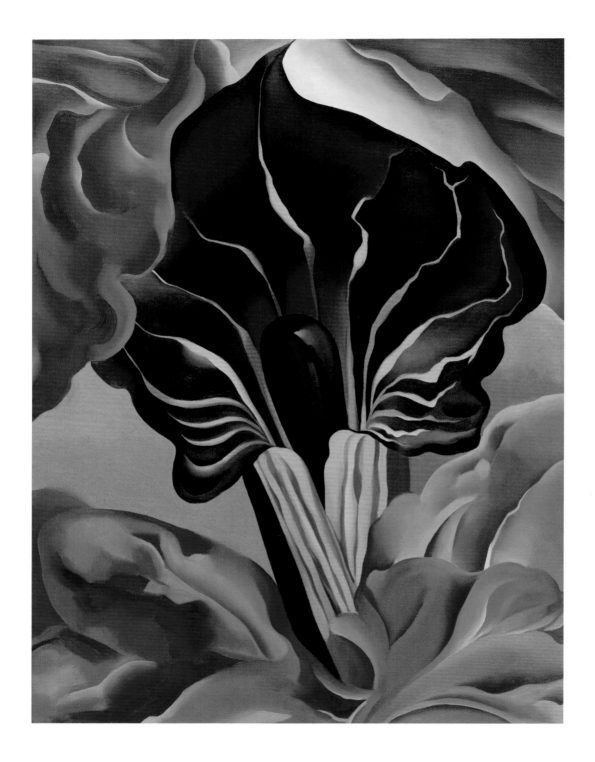

44
Jack-in-the-Pulpit No. II, 1930
Oil on canvas
101.6 × 76.2 cm (40 × 30 in)
National Gallery of Art, Washington, DC

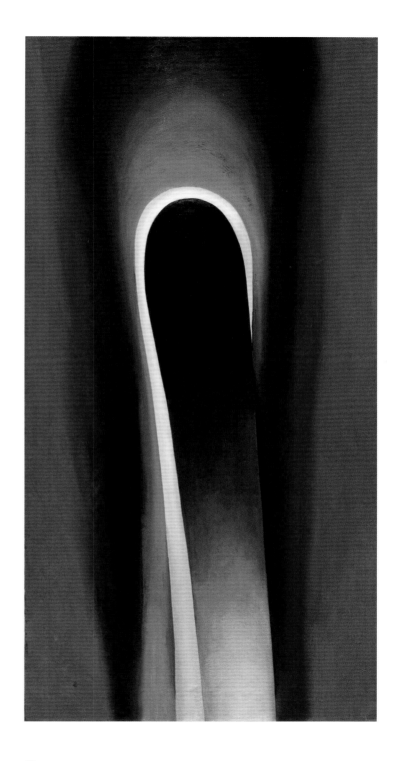

45
Jack-in-the-Pulpit No. VI, 1930
Oil on canvas
91.4 × 45.7 cm (36 × 18 in)
National Gallery of Art, Washington, DC

FOCUS (4)

THE QUESTION OF GENDER

So what explains O'Keeffe's indignation over the erotic readings of her work? First of all, many of her flower paintings do not resemble vaginas or penises, for instance *Blue Morning Glories* [50] and *Jimson Weed* [51], and thus possess no sexual frisson. But, even for those that do, such as her iconic depictions of irises [48, 49], she would probably have thought such interpretations reductive caricatures. Her portrayals of flowers are about various things, above all morphology and colours. Always a formalist at heart, O'Keeffe said, in a statement that echoes the ideas of Dow, 'The subject matter of a painting should never obscure its form and color, which are its real thematic contents.'

Feminists in the 1970s, including the artist Judy Chicago, embraced O'Keeffe as a trailblazer for their cause. Chicago's *The Dinner Party* [46] presents a feminist pantheon of women poets, novelists, rulers, goddesses and artists from across the millennia. The names of 999 women are noted on floor tiles and an additional 39 women, including O'Keeffe, are given their own place settings with vaginal ceramic plate 'portraits'. The feminist

co-option of her art enraged O'Keeffe, who stated emphatically, 'I am not a woman painter!' By this time, she was already firmly ensconced in the pantheon of American art – as strongly as Winslow Homer (1836–1910), Mary Cassatt (1844–1926) and Edward Hopper (1882–1967) – and did not want her achievement typecast or marginalized in any way.

Yet, in spite of O'Keeffe's negative reaction to the feminists' views, she was an exception in her day and was continually made aware of her gender in an art world where galleries, schools, museums and criticism were dominated by men. O'Keeffe was a member of the pro-suffrage National Women's Party and once said, 'I believe in women making their own living. It will be nice when women have equal opportunities and status with men so that it is taken as a matter of course.' In many ways her life incarnated the message of Virginia Woolf's iconic essay *A Room of One's Own*. Though Woolf came from a relatively elite section of British society, she and O'Keeffe shared the belief that women, in the same way as men, needed

46
Judy Chicago (b. 1939)
Georgia O'Keeffe plate from
The Dinner Party, 1979
China paint on porcelain,
36.8 × 35.6 × 12.1 cm
(14 ½ × 14 × 4 ¾ in)
Brooklyn Museum, New York

the opportunity to be self-sufficient. In addition, both believed that women required their own private space if they were to nurture creativity.

Yet O'Keeffe never did wave a feminist flag as a painter. Indeed, she disdained political art, which she found illustrative and lowbrow, and she would have agreed with Oscar Wilde's 'Art for Art's Sake' statement that 'All art is quite useless'. When the US was reeling from the Great Depression, the editor of the Marxist journal *New Masses* accused her of insensitivity as an artist to the needs of the poor. In a public debate with him, she defended herself by saying that, as a respected and successful artist, she offered a model for women in general. The critics Anna Chave and Anne Wagner have argued convincingly that O'Keeffe altered her art in the 1920s, turning to the flowers so that she could explore the female body and its experiences. O'Keeffe herself said that she was 'trying ... to do painting that is all of a woman'.

For Judy Chicago and others, O'Keeffe's great achievement was that she created a fearlessly candid – though metaphoric – representation of the female body, one entirely different from the tradition of female nudes painted by male artists for a male audience. In considering the female body from a woman's perspective, and openly exploring female sexuality, O'Keeffe's approach presaged the art of Louise Bourgeois [47], Eva Hesse (1936–1970), Ana Mendieta (1948–1985) and a host of others. So, in the minds of many, whatever her politics, O'Keeffe offered women artists a self-empowering model of female independence.

But there is no denying that the flower pictures also perpetuated stereotypes about women artists as flower painters, and also reinforced the view that they personify sensuality, feeling and fecundity and are inherently mysterious creatures. This conception of feminine otherness continues to appeal today; O'Keeffe's authority still has much to do with the perception that she was an avatar of femininity. Thus, in her flower paintings, O'Keeffe simultaneously exploited long-standing gender associations with flowers and recast the genre to present herself as an uninhibited 'modern' woman and vanguard artist.

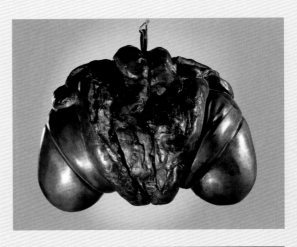

47
Louise Bourgeois (1911–2010)
Janus Fleuri, 1968
Bronze, golden patina
25.7 × 31.7 × 21.2 cm
(10 ½ × 12 ½ × 8 ⅜ in)
Robert Miller Gallery, New York

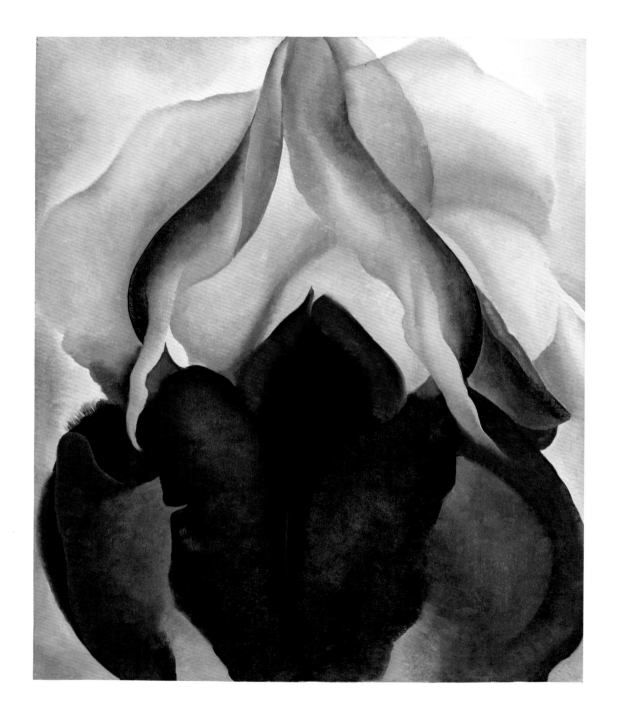

48
Black Iris, 1926
Oil on canvas
91.4 × 75.9 cm (36 × 29 ⅞ in)
The Metropolitan Museum of Art, New York

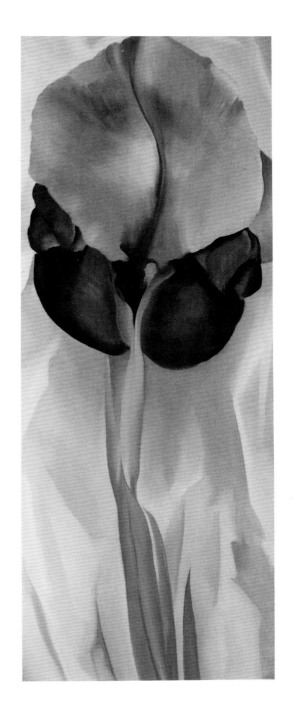

49
Dark Iris, 1927
Oil on canvas
81.3 × 30.5 cm (32 × 12 in)
Colorado Springs Fine Arts Center

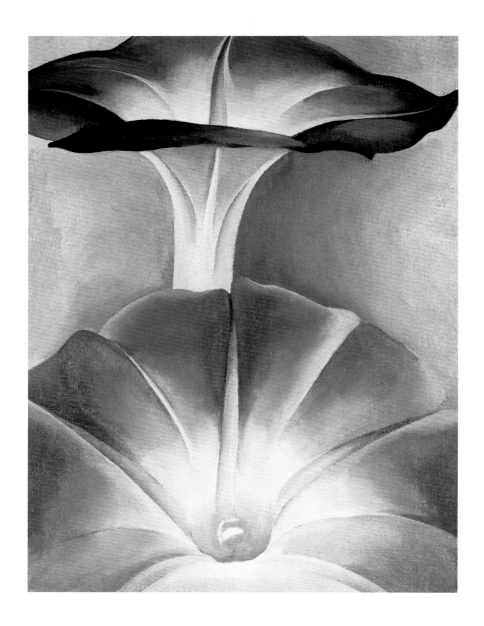

50
Blue Morning Glories, 1935
Oil on canvas
31.2 × 22.9 cm (12 ¼ × 9 in)
Private collection

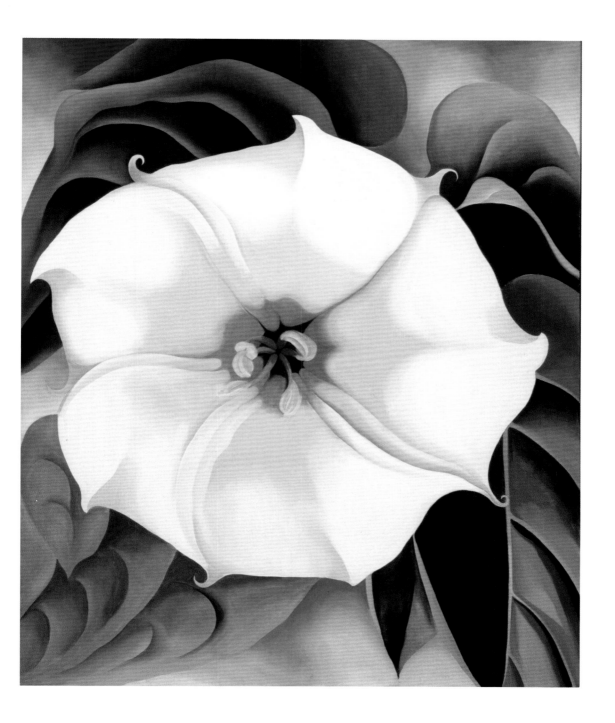

51
Jimson Weed, 1932
Oil on canvas
121.9 × 101.6 cm (48 × 40 in)
Georgia O'Keeffe Museum,
Santa Fe

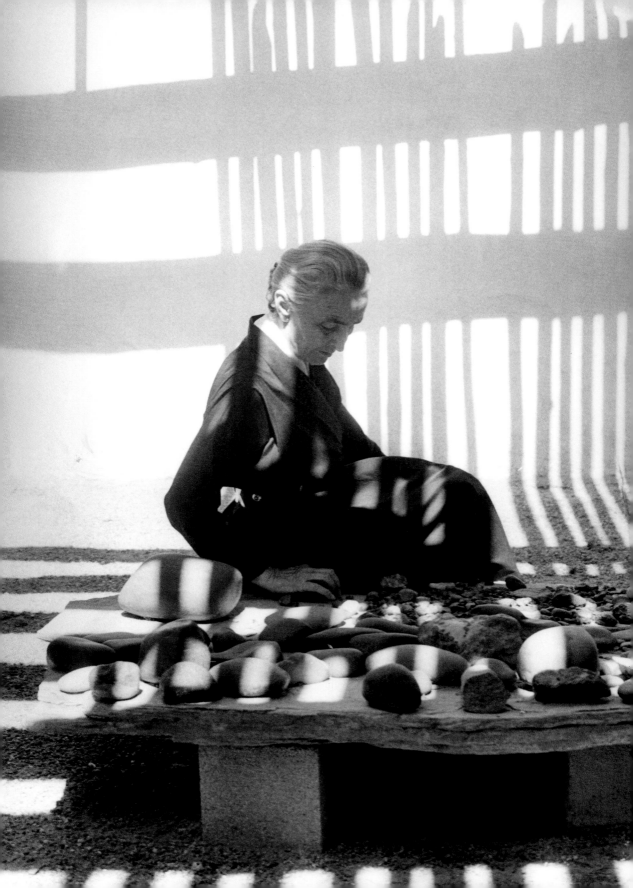

STILL LIFE AND TREES

In the 1920s, while staying at the Lake George home, O'Keeffe and Stieglitz
often made pictures of the apple trees and their fruit. The prestigious award
for still life O'Keeffe received while studying in New York may have encouraged
her to explore that genre again, yet her main inspiration seems to have
been Paul Strand's remarkable photographs of ordinary objects from a close
perspective, which marry verisimilitude and abstraction.

[5]

[34]

STILL LIFES

[53]

Like Strand's still lifes, O'Keeffe's *The Green Apple* exemplifies the force
of concision. The painting reduces its subject matter to a green ovoid and
a black circle within a blue-grey rectangle. The plate is suspended in an
un-defined space, the apple seems to hover strangely above the plate. For the
sake of visual cohesion, O'Keeffe extended the colour of the dark plate around
the top of the fruit. Because apples were traditional emblems of rural
America, her depictions can be understood in part as a nostalgic evocation
of an earlier pre-industrial time.

In the 1920s, O'Keeffe produced numerous still lifes of a range of fruits
and shells, as well as eggs. She was once more beguiled by pristine round
forms. Like Edward Weston's and Edward Steichen's close-up photographs
of shells from several years later, *Shell No. 1*, in typical American modernist
fashion, couples realism and non-objectivity. O'Keeffe, Weston and Steichen
pictured isolated shells as miracles of stripped-down elegance. During
this period, O'Keeffe also created several depictions of peaches. One of those
works, *Peach*, draws from the Victorian still life convention of showing
wrapped fruit. The subject offered O'Keeffe an overt way to express her belief
that nature was a great gift, something radiant that has the power to inspire.

[56]

[57]

TREES

[54]

At the same time as O'Keeffe was painting still lifes, she was also doing
a series depicting trees on the Lake George property. Her teacher Dow had
encouraged his students to render trees as a compositional exercise. Still,
Stieglitz – who had been photographing the trees at Lake George for several
years – was a more immediate influence, although he and O'Keeffe differed
markedly in their treatment of the subject. Where Stieglitz was mainly inter-
ested in capturing the specific character of each tree, with its particular
textures and outlines, O'Keeffe simplified their forms and found mystery in
the subject itself. For example, her *Birch and Pine Tree No. 1*, with its weirdly

◄ O'Keeffe's central patio at her Abiquiu house, New Mexico, 1966.

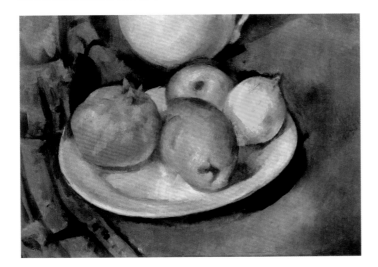

52
Paul Cézanne
(1839–1906)
*Still Life with
Pomegranate, Pears
and Lemon*, 1893–4
Oil on canvas
26.7 × 35.6 cm
(10½ × 14 in)
Private collection

anthropomorphic birch, creates the feeling of a haunted wood, perhaps the setting for a dark northern folk tale. Nature was a constant generator of new motifs and colours for O'Keeffe, and her representations of trees vary greatly.

Starting in the 1920s, O'Keeffe repeatedly drew from the language of Cubism when she painted a series of trees that stand in shifting and ambiguous spaces, their rhythmically curving branches dissolving into the backgrounds. Few of her other paintings convey a sense of flux or movement as these do. O'Keeffe always denied being influenced by the French Post-Impressionist Paul Cézanne, but some of her still lifes and works like *Grey Tree, Lake George* are conversant with his depictions of trees (along with those of Charles Demuth), particularly in the way that foreground and background collapse into one another. Lastly, the tree was a well-established symbol in the late nineteenth and early twentieth centuries of art's capacity for creative growth. [52, 55]

► FOCUS (5) COASTAL MAINE, P.74

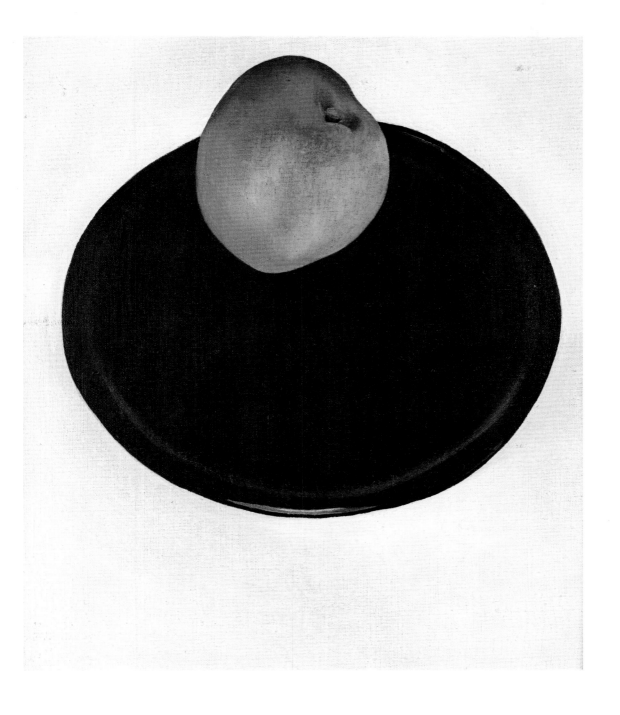

53
The Green Apple, 1922
Oil on canvas
35.9 × 31.8 cm (14 ⅛ × 12 ½ in)
Birmingham Museum of Art, Alabama

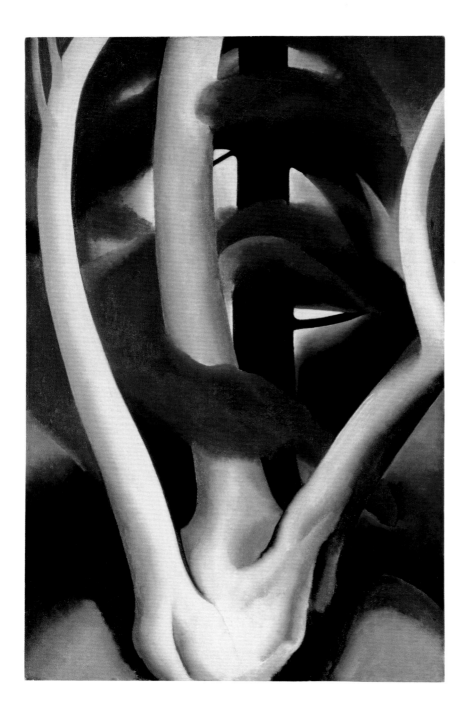

54
Birch and Pine Tree No. 1, 1925
Oil on canvas
88.9 × 55.9 cm (35 × 22 in)
Philadelphia Museum of Art

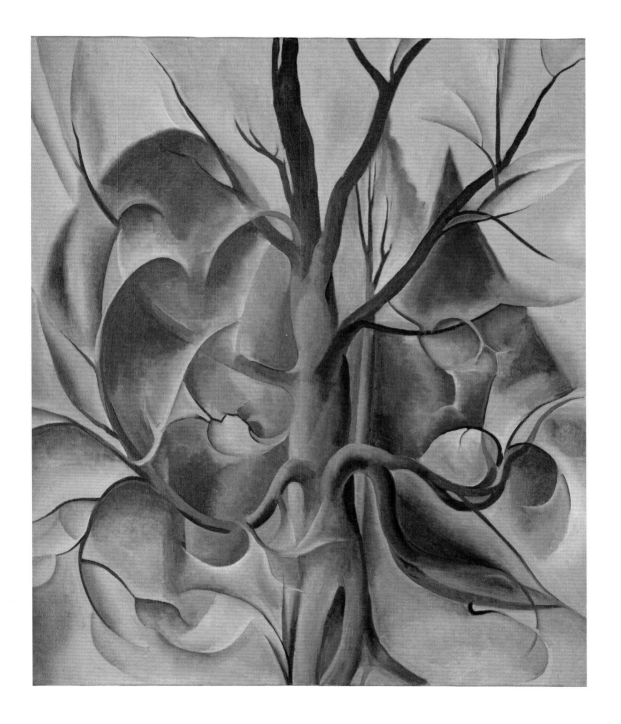

55
Grey Tree, Lake George, 1925
Oil on canvas
91.4 × 76.2 cm (36 × 30 in)
The Metropolitan Museum of Art, New York

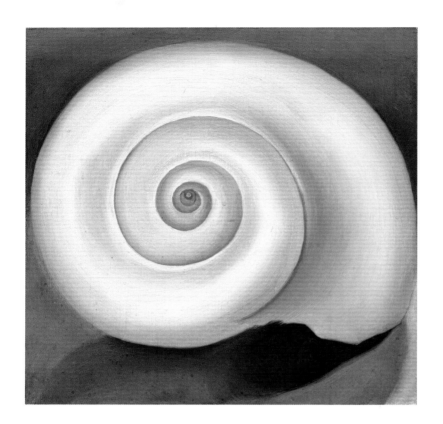

56
Shell No. 1, 1928
Oil on canvas
17.8 × 17.8 cm (7 × 7 in)
National Gallery of Art, Washington, DC

Over the years, O'Keeffe collected many
shells, which she displayed in her various
houses alongside her rocks and bones. The
rounded purity of the shells perfectly suited
her aesthetic tastes.

57
Peach, 1927
Oil on panel
17.8 × 22.2 cm (7 × 8 ¾ in)
Yale University Art Gallery,
New Haven

FOCUS ⑤

COASTAL MAINE

In the 1920s, O'Keeffe made several extended trips to York Beach, Maine. Stieglitz accompanied her on only one of those sojourns, thus she may have viewed the others as a pleasant escape from his increasingly controlling egotism and paternalistic arrogance. The photographer Edward Steichen, who worked with Stieglitz for years, felt that he 'only tolerated people close to him when they completely agreed with him and were of service'.

O'Keeffe found Maine entrancing, saying, 'I loved ... watching the waves come in, spreading over the hard wet beach – the lighthouse steadily bright far over the waves.' Her marvellous *Wave, Night* [59] captures her memory of the place. Other than a few expansive views of Lake George, she had produced nothing like this since she lived in West Texas and had only rarely painted night scenes (mainly of skyscrapers).

Coastal Maine suited her proclivity for distillation, while the night view offered her another opportunity to explore a limited palette, here mauve, green and grey-blue. Late in life she would express admiration for the work of Mark Rothko: this scene looks forward to his luminous floating rectangles [107].

Wave Night presents a dialogue between nature and culture, the tiny pinpoint of the lighthouse a counterpoint to the large waves, each demarking space and time. Beside Marsden Hartley's depictions of thundering waves in Maine [58], which are tributes to Winslow Homer's earlier iconic pictures from Prout's Neck, Maine, *Wave, Night* is calm, still and eternal, a message reinforced by its effacement of brushstrokes. By contrast, Hartley's scene stresses the brushmarks, exposing the paint's materiality.

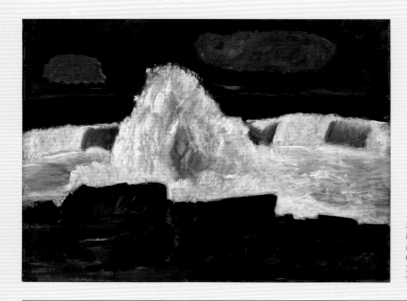

58
Marsden Hartley (1877–1943)
Evening Storm, Schoodic, Maine, 1942
Oil on composition board
76.2 × 101.6 cm (30 × 40 in)
The Museum of Modern Art, New York

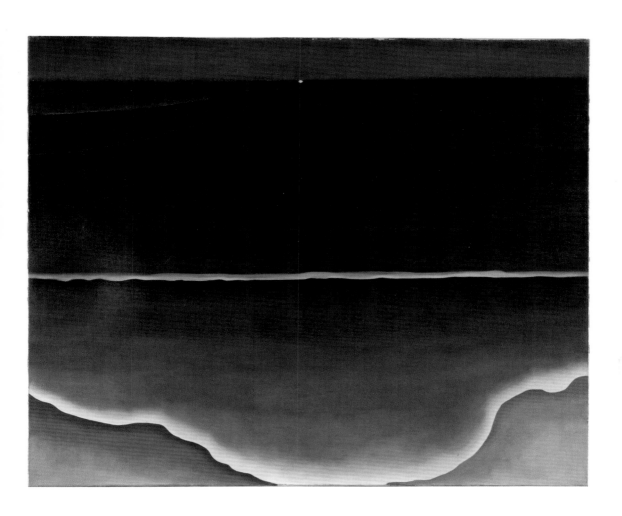

59
Wave, Night, 1928
Oil on canvas
76.2 × 91.4 cm (30 × 36 in)
Addison Gallery of American Art,
Phillips Academy, Andover

SKYSCRAPERS

One does not normally associate O'Keeffe's art with city scenes. Yet she spent decades living in New York City and did more than a dozen views of its streets, bridges and skyscrapers, mainly between 1925 and 1929. There is no question that this marked a departure from her depictions of nature. Indeed it is at first difficult to reconcile her love of the natural world with her scenes of New York buildings.

In November 1925 O'Keeffe and Stieglitz moved into an expensive apartment in the newly opened Shelton Hotel in midtown Manhattan, the first New York hotel that was also a skyscraper. They spent their winters there until 1936, staying on various floors from the eleventh to the thirtieth, sometimes with a large roof garden and unobstructed views of the city.

It was O'Keeffe who wanted to move there. By 1925 she was earning a sizeable income from the sale of her paintings. Two years later, a group of her works sold for $17,000, and in 1928 six of her calla lily paintings sold for $25,000 (though, owing to the economic crash the following year, that sale was never completed). O'Keeffe's growing revenue gave her more autonomy from Stieglitz. It also afforded her the opportunity to paint aerial views of the city, such as *East River from the 30th Story of the Shelton Hotel*.

[65]

EMBLEMS OF MODERNITY

It was mainly the city's tall buildings that roused O'Keeffe's imagination. On one level, her portrayals of skyscrapers can be understood as a rejoinder to those who had labelled her a quintessential woman artist, just a painter of flowers. What could be more 'masculine' than a skyscraper? They appealed to her love of crisp contours and the interaction of positive and negative space.

Her choice of subject was also influenced by the cultural moment. America was in the middle of an economic boom, which only ended with the Great Depression of 1929, and at this time New York saw its skyline transformed by a burst of construction. The skyscraper became an emblem of American engineering prowess and a personification of modernity. No city in Europe had such tall buildings. Typically, skyscrapers were seen through the prism of American exceptionalism. For instance, the cultural critic Edward Rush Durer claimed that skyscrapers had 'nothing to do with Europe or the past; they are symptomatic of America'.

Since the 1890s, numerous American illustrators and artists, including Childe Hassam (1859–1935), Joseph Pennell (1857–1926), George Bellows (1882–1925) and Stieglitz, had depicted New York's skyscrapers. In the wake of Cubism, their geometric forms became even more appealing to artists.

◄ O'Keeffe at her ranch home, New Mexico, 1966.

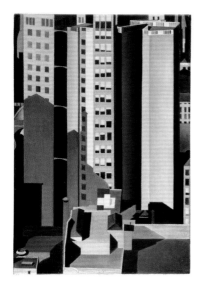

60
Charles Sheeler (1883–1965)
Skyscrapers, 1922
Oil on canvas
50.8 × 33 cm (20 × 13 in)
The Phillips Collection, Washington, DC

A group of American painters and photographers in the 1920s and 1930s, who are loosely labelled as Precisionists, pictured bridges, dams, factories, machines and tall buildings, mostly without any human figures. *Skyscrapers* by Charles Sheeler epitomizes how these artists rendered buildings as abstract shapes and how their paintings emulate the look of photography, in part by suppressing the brushwork. It is not hard to discern the influence of Sheeler on O'Keeffe's paintings such as *City Night*. Of course, she also knew Stieglitz's earlier photographs of New York skyscrapers and was familiar with the Whistlerian tradition of night views of cities in early twentieth-century American photography.

[60]

[61]

[62]

A DISTINCTIVE VIEW

Even considering the influence of other artworks, O'Keeffe's images of New York are very distinctively her own. *City Night*, for example, differs from the portrayals of Sheeler and Stieglitz by employing tapering vertical lines and a dizzying, vertiginous perspective that amplifies the height of the buildings. The inhuman scale of the edifices in *City Night* and the sense of standing in a claustrophobic canyon give the image an ominous character, as if the skyscrapers were intended as symbols of uncaring corporate power (perhaps a nod to Paul Strand's sinister portrayal of Wall Street from 1916). Thus, *City Night* differs from most Precisionist imagery, which is steeped in an uncritical, stereotypically masculine faith in technology. O'Keeffe's *East River from the 30th Story of the Shelton Hotel* also contrasts with many contemporary urban scenes for showing a bustling, though still Cubistic, city. This is one of eight depictions of the East River she made between 1926 and 1929. The images are informed by a sense of privilege. Few Americans could afford apartments with such elevated views.

[64]

O'Keeffe's *The Shelton with Sunspots, N.Y.* is one of several New York renderings that are laced with her wit. The painting was inspired by a morning street view of the Shelton Hotel when she looked up at it and saw 'the optical illusion of a bite out of one side of the tower made by the sun, with sunspots against the building and against the sky'. The sunspot can be interpreted as an attempt to puncture the mythic status of the skyscraper, as the sun proclaims its dominion by 'taking a bite' out of the building.

[63]

O'Keeffe was also beguiled by Raymond Hood's Radiator Building, a classic example of Art Deco architecture. In her *Radiator Building – Night, New York*, the building seems to be wearing a colossal hat in the shape of a Chinese pagoda. O'Keeffe saw the Radiator Building as a kind of magical organism. She said that it was like 'a tall thin bottle with colored things going up and down inside'. Her rendering of it turns the building into a decorative pattern of rectangles, like stained glass, as if to express the popular conceit that skyscrapers were cathedrals for commerce.

[30]

With *Radiator Building – Night, New York*, O'Keeffe claimed the city as her own, using her characteristic undulating lines to represent the steam in the upper right and radiating lines behind the structure, both of which are present in earlier works such as *Blue and Green Music*. She also made the painting self-referential by replacing the words 'Scientific American' in a red neon sign, on the left, with 'Alfred Stieglitz'. This homage to her husband acknowledges his place in the city's cultural constellation and the way his myriad photographs of New York had colonized it. The deep cadmium red she employed for the sign gives it an infernal quality, perhaps an effort to cast Stieglitz as bohemian. In recalling the way he had described O'Keeffe's flower paintings as proof of his own sexual prowess, the neighbouring Radiator Building can be read as a huge (and somewhat amusing) phallic emblem of male authority.

► FOCUS ⑥ AN AMERICAN PLACE, P.84

61
Berenice Abbott (1898–1991)
New York Telephone Building, 1935
Gelatin silver print
24.1 × 19.1 cm (9 ½ × 7 ½ in)
Museum of the City of New York

62
City Night, 1926
Oil on canvas
121.9 × 76.2 cm (48 × 30 in)
The Minneapolis Institute of Arts

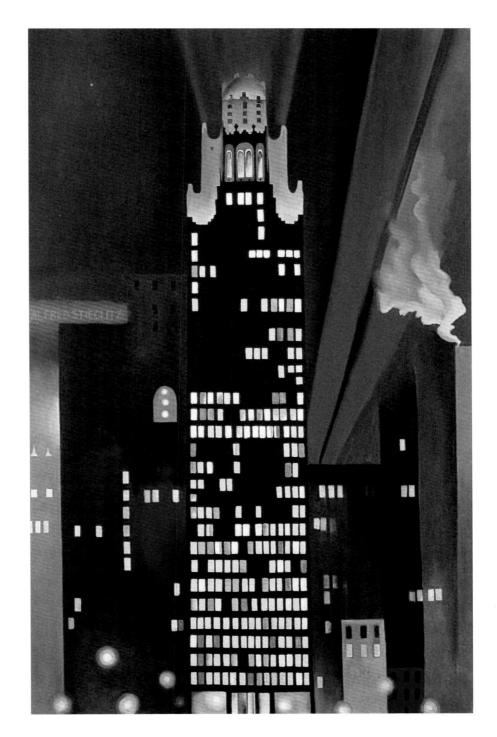

63
Radiator Building – Night, New York, 1927
Oil on canvas
121.9 × 76.2 cm (48 × 30 in)
The Carl Van Vechten Gallery,
Fisk University, Nashville

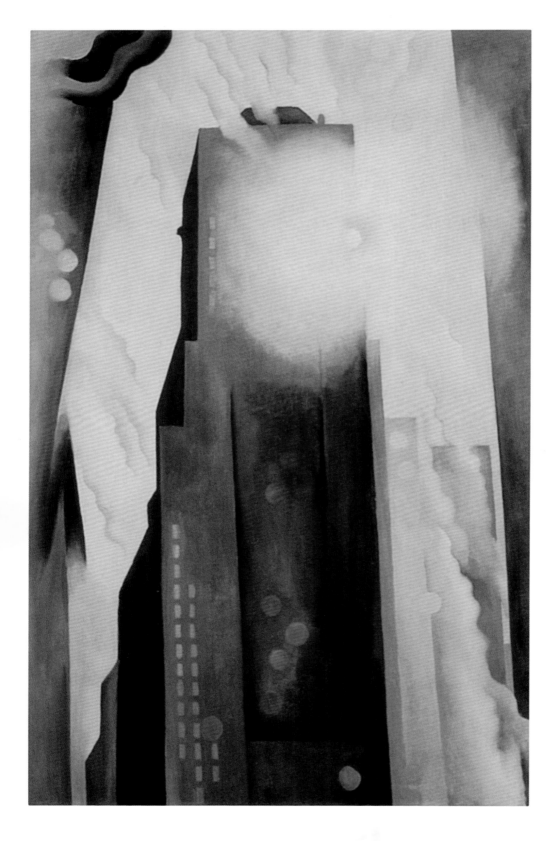

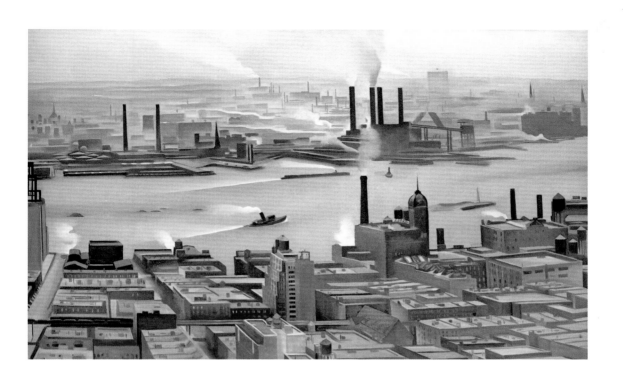

◄ 64
The Shelton with Sunspots, N.Y., 1926
Oil on canvas
123.2 × 76.8 cm (48 ½ × 30 ¼ in)
The Art Institute of Chicago

This painting demonstrates O'Keeffe's debt to
modernist photography, especially Stieglitz's city
views. The sunspots that form a decorative pattern
across the painting emulate the effect of looking
at the sun through the lens of a camera.

65
*East River from the 30th Story of the
Shelton Hotel*, 1928
Oil on canvas
76.8 × 121.9 cm (30 ¼ × 48 in)
New Britain Museum of American Art,
Connecticut

FOCUS ⑥

AN AMERICAN PLACE

During the years O'Keeffe was painting her skyscrapers, she also depicted the barns on the Lake George property. Following the example of Stieglitz, who had taken serial photographs of these barns in 1923, she painted several versions of them, including *Lake George Barns* [67] and *Barn with Snow* [68]. Against its sombre palette of greys, greens and blues, the small red building on the left is wonderfully ostentatious, like a dandy attending a Puritan church service. O'Keeffe's remarkable *Farmhouse Window and Door* [66] is a flattened, monochromatic rendering of a detail of the main house at Lake George. Other than the lively flourish of ornament above the door, it appears humble and unadorned. The painting reduces its subject to an abstracted architectural lexicon of 'door', 'shutters' and 'clapboard siding'. No painting from the period better epitomizes the allure of the vernacular for American artists.

In the 1920s and 1930s, American painters and photographers commonly pictured vernacular architecture (designed by carpenters rather than schooled architects). The vernacular had great authority as an emblem of American identity and struck a chord with artists, composers, novelists, historians, poets, collectors and cultural critics. The handmade and the rustic – from folk art to rural churches – were thought to be deeply rooted in the nation's soil and antithetical to industrialization and mass consumerism.

If the vernacular personified the virtues of an earlier America, it was also bound to the idea of place. The local or regional became a ubiquitous theme in the nation's art, and place became another signifier for the genuinely 'American'. This accounts for Stieglitz naming his new gallery 'American Place' in 1929.

American artists had relied on European models since colonial times in the seventeenth century, and the issue of what constituted 'Americanness' in art had long been a vexing one. The introduction of modernism in the twentieth century further sharpened that debate. Stieglitz cast himself and his circle of artists as all-American, stating firmly, 'I was born in Hoboken. I am an American.'

Similarly, O'Keeffe was at pains to emphasize her national character, underscoring the point that she had 'not been to Europe' and was uninterested in foreign masters like Cézanne. Thus, her paintings of the Lake George barns were in part meant to demonstrate her lack of indebtedness to European models. From this point until the end of her career, she proudly wore a badge of Americanness.

Most accounts of O'Keeffe's Lake George pictures fail to situate them within the larger context of American Scene painting (realist paintings of different aspects of American life, produced in the 1920s and 1930s). Normally this movement and modernism are cast as antithetical to one another. Yet, many of the so-called American Scene artists – including Edward Hopper, George Ault (1891–1948), Charles Burchfield and Alexander Hogue (1898–1994) – similarly coupled the vernacular and the geometric. An exploration of the local is also a hallmark of this type of painting. Thus, O'Keeffe's barn pictures were closely aligned with the work of many artists from this period.

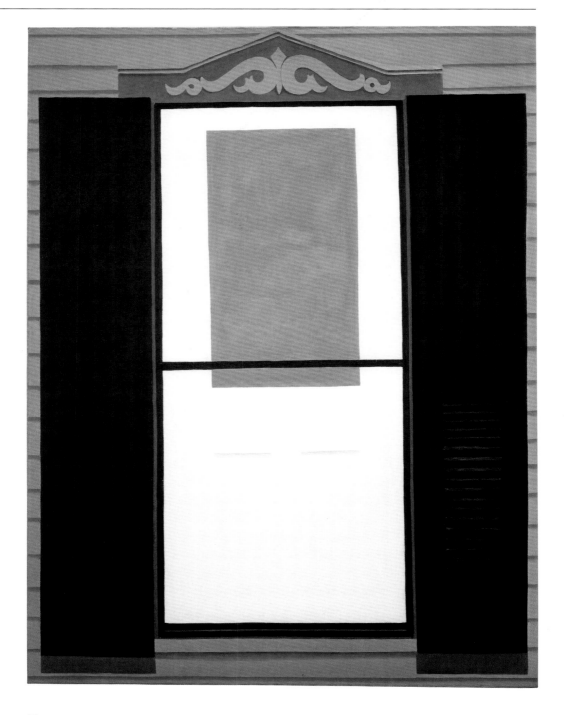

66
Farmhouse Window and Door, 1929
Oil on canvas
101.6 × 76.2 cm (40 × 30 in)
The Museum of Modern Art, New York

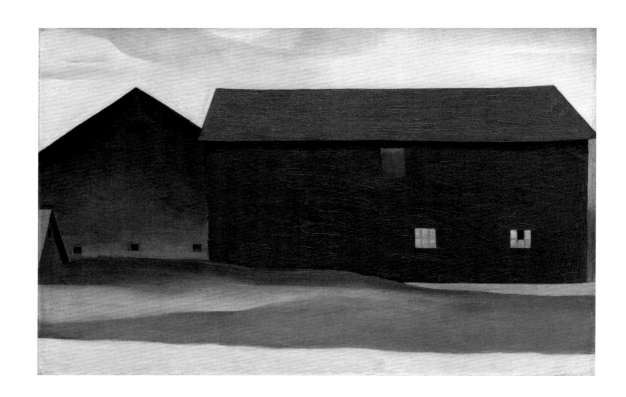

67
Lake George Barns, 1926
Oil on canvas
53 × 81.6 cm (20 ⅞ × 32 in)
Private collection

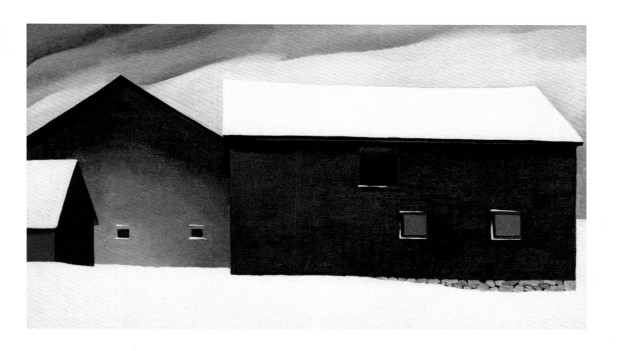

68
Barn with Snow, 1934
Oil on canvas
40.6 × 71.1 cm (16 × 30 in)
San Diego Musem of Art

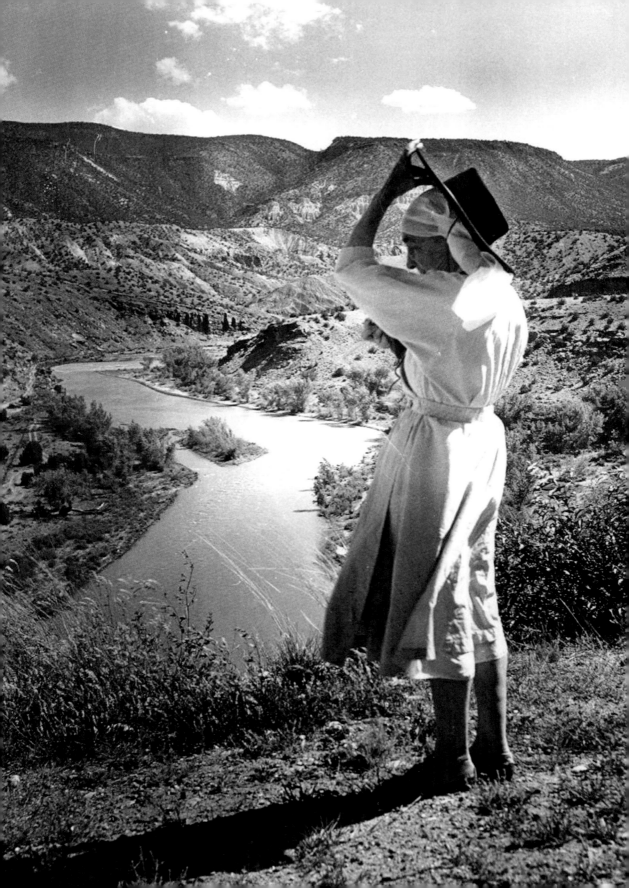

FIRST TRIP TO TAOS

In spring 1929, O'Keeffe travelled to Taos, New Mexico, with Rebecca Strand and spent about five months at the home of the wealthy and eccentric art patron Mabel Dodge Luhan. New Mexico had become a tourist destination, a place to see Native American dances, prehistoric ruins, Spanish colonial churches and the Rocky Mountains. Taos was, and still is, a small, remote town with an art colony. Located in the high desert, it sits at the base of pine-covered mountains. O'Keeffe learned about Taos from Strand and Marsden Hartley, both of whom had recently been there.

The opportunity to travel to New Mexico occurred at a time when O'Keeffe undoubtedly wanted distance from Stieglitz. Not only had she tired of his arrogant, demanding and mercurial nature, but she was aware of his affair with Dorothy Norman, a beautiful young assistant at his aptly named Intimate Gallery in New York. O'Keeffe's first trip to New Mexico should, therefore, be understood as a declaration of freedom from her husband. Despite Stieglitz's opposition she even bought an automobile, a Model A Ford.

PAINTING THE DESERT

This was a watershed in O'Keeffe's career. New Mexico presented a wide array of fresh subjects to paint that were congenial to her temperament. She chose to portray the desert as a timeless, exotic world filled with colonial churches and menacing crosses, a site of enigmatic symbols and visual poetry.

The sweeping landscape, with its brightly coloured sandstone formations, also offered entirely new possibilities. The light, space and hues of the area truly do differ – vibrantly and majestically – from the landscapes and urban areas already familiar to her. It was in this harsh desert climate that she discovered skulls and bones of different types of animals, objects that she would bring to life in her pictures. Despite the changes in O'Keeffe's Taos work, these scenes continue to express her interest in nature, the vernacular, and in capturing a sense of place.

RANCHOS CHURCH

O'Keeffe's first extended pictorial series of New Mexico was devoted to a small, late eighteenth-century Spanish colonial church in Ranchos de Taos, a tiny village just outside Taos. Between 1929 and 1931 she produced several preparatory drawings and seven oils depicting this building.

This church was a popular subject with many artists. As O'Keeffe wrote, 'Most artists who spend any time in Taos have to paint it, I suppose, just as they have to paint a self-portrait.' The structure was widely admired for its

[71, 72]

◄ O'Keeffe in New Mexico overlooking Chama River, 1961.

stark simplicity and monumentality. The photographer and environmentalist Ansel Adams described the church as 'an outcropping of the earth rather than merely an object constructed upon it'. [69]

When O'Keeffe painted the church, prototypes such as these were very much on her mind. Like other modernists, she made the building appear as massive and enduring as a Western mesa. Though the church is located in the middle of a plaza and is a central part of the village social fabric, the modernist renderings, including O'Keeffe's, transform it into an isolated, late Cubist sculpture: in the words of Adams, a 'magnificent form'. As shown in O'Keeffe's painting, the building looks inscrutable, as if it were guarding something mysterious within. Her paintings of the Ranchos church are odes to the vernacular, analogous to *Baptism in Kansas* by John Steuart Curry, [70] which presents religious faith in a somewhat satirical light, though still as synonymous with American identity.

THE CROSSES

On her first trip to Taos, O'Keeffe also began a sequence of paintings depicting the crosses that she saw on the northern New Mexico hillsides. These canvases continued her exploration of the area's Hispanic culture, which to her seemed exotic, revealing her interest in vernacular expressions of Christian symbolism. O'Keeffe's depictions of the Ranchos church celebrate the aesthetic legacy of Spanish colonialism, but her paintings of the crosses express indignation. As she wrote, 'I saw the crosses so often – and often in unexpected places – like a thin dark veil of the Catholic Church spread over the New Mexico landscape.'

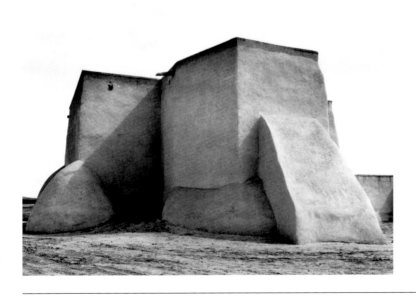

69
Ansel Adams
(1902–1984)
St Francis Church,
Ranchos de Taos,
New Mexico,
c.1929
Gelatin silver print

70
John Steuart Curry
(1897–1946)
Baptism in Kansas, 1928
Oil on canvas
101.6 × 127 cm
(40 × 50 in)
Whitney Museum of
American Art, New York

To O'Keeffe, the crosses symbolized the Catholic Church as oppressor, implying that the distant colonial past still cast a heavy shadow over the land. Her portrayal of New Mexico crosses vary greatly in tone, with some, such as [73] *Black Cross with Stars and Blue*, casting the cross as a link between earth and sky, this life and heaven. The blue in those paintings recall Kandinsky's comment that blue is inherently spiritual. Yet, even in her soothing depictions of crosses, they still ominously dominate the landscape.

[74] Some of her other pictures of crosses, such as *Black Cross with Red Sky*, also evoke the Penitentes, a mystical confraternity of indigenous people in northern New Mexico and southern Colorado, formed in the eighteenth century. O'Keeffe wrote that on her summer visits to New Mexico she had 'heard the Penitente songs'. Members of this private brotherhood, which was not recognized by the Roman Catholic Church, practised torturous religious rituals based on Christ's suffering. Starting at Lent each year, the Penitentes flagellated themselves and tied long-spined cacti to their backs. Then, on the Christian Good Friday, they re-enacted the crucifixion in secret ceremonies.

To most Americans, the Penitente Brotherhood would have seemed as alien as anything in Joseph Conrad's *The Heart of Darkness*. This group's spectacularly macabre rituals drew numerous artists in the early twentieth century to picture their processions and crucifixions. Although O'Keeffe's *Black Cross with Red Sky* shows no one on the cross, in the context of northern New Mexico at this time, its lurid flaming background is clearly meant to evoke the Penitente ceremonies.

▶ FOCUS ⑦ LAWRENCE'S TREE, P.96

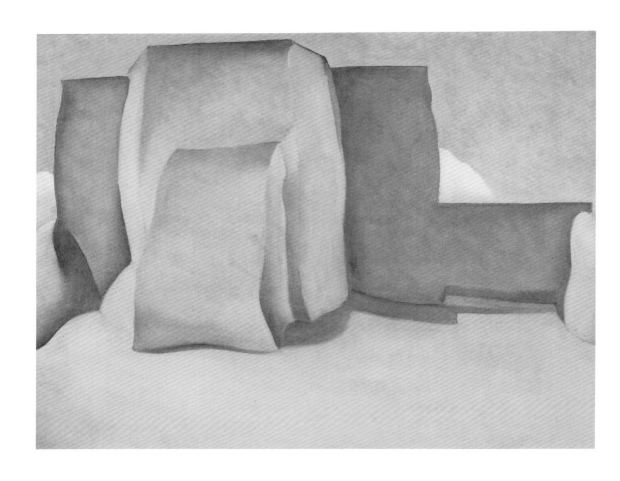

71
Ranchos Church No. 1, 1929
Oil on canvas
47.6 × 61 cm (18 ¾ × 24 in)
Norton Museum of Art,
West Palm Beach

72 ►
Church Steeple, 1930
Oil on canvas
76.2 × 40.6 cm (30 × 16 in)
Georgia O'Keeffe Museum,
Santa Fe

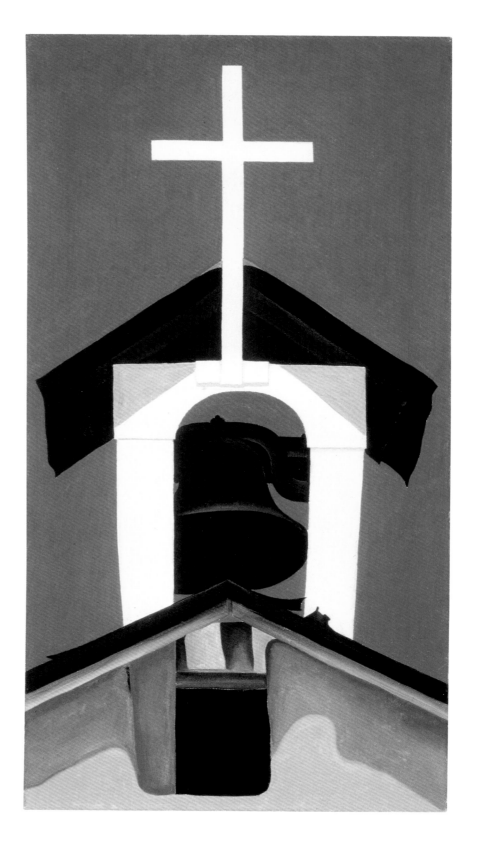

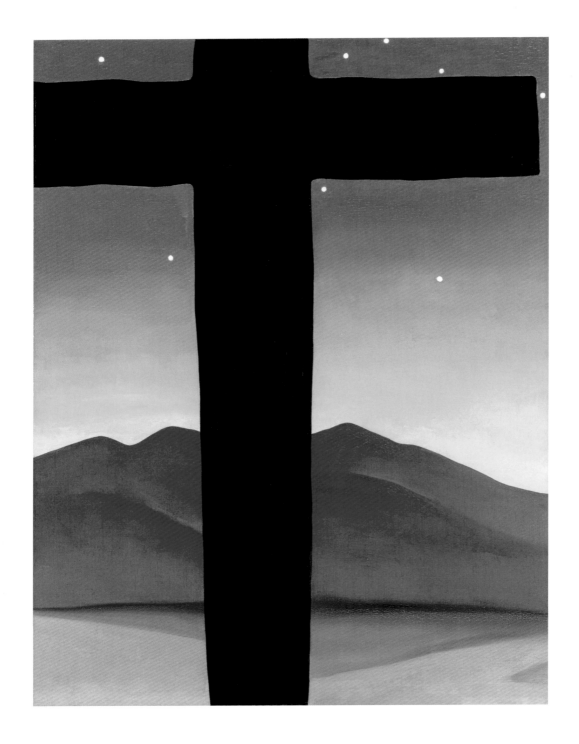

73
Black Cross with Stars and Blue, 1929
Oil on canvas
101.6 × 76.2 cm (40 × 30 in)
Private collection

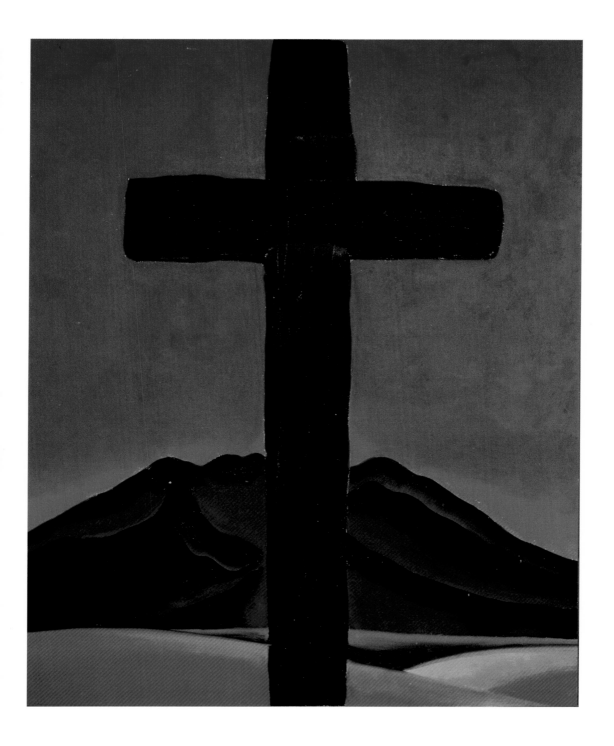

74
Black Cross with Red Sky, 1929
Oil on canvas
101.6 × 81.3 cm (40 × 32 in)
Gerald Peters Gallery, Santa Fe

FOCUS

LAWRENCE'S TREE

During the summer of 1929, O'Keeffe spent several weeks at D. H. Lawrence's former ranch north of Taos, where Lawrence and his wife Frieda had lived for about a year in 1922. O'Keeffe was enthralled by Lawrence's writing, with its exaltation of nature, and sex, as a source of redemptive spirituality. It is appropriate that she saluted Lawrence by painting the tall ponderosa pine tree that stands in front of the small Lawrence home [76].

O'Keeffe wrote, 'There was a long weathered carpenter's bench under the tall tree in front of the little old house ... I often lay on that bench looking up into the tree.' Like the buildings in her earlier New York scenes, the tree reaches for the night sky, but now its top seems to be communing with the stars, a lovely metaphor for inspiration. The painting is at once a personification of Lawrence (the tree's red branches resemble blood vessels) and a tribute to his artistic genius.

O'Keeffe's picture also reaches back to Van Gogh's depictions of trees that link earth and heaven [75]. O'Keeffe and Van Gogh shared an interest in cosmic connections, exploring visionary pantheism and feelings of ecstatic awe. O'Keeffe later wrote that she did not feel the need to attend a church because 'when I stand alone with the earth and sky a feeling of something in me going off in every direction into the unknown infinity means more to me than anything any organized religion gives me'.

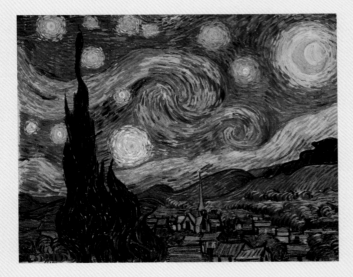

75
Vincent van Gogh (1853–1890)
The Starry Night, 1889
Oil on canvas
73.7 × 92.1 cm (29 × 36 ¼ in)
The Museum of Modern Art, New York

76
The Lawrence Tree, 1929
Oil on canvas
78.7 × 101.6 cm (31 × 40 in)
Wadsworth Atheneum, Hartford

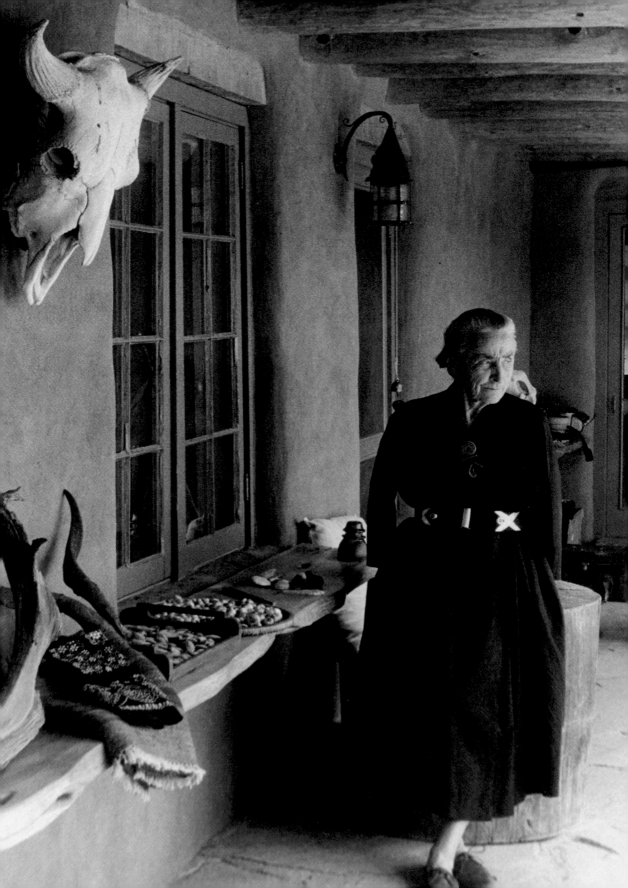

SKULLS, BONES AND LANDSCAPES

Following her initial visit, O'Keeffe returned to Taos for the next two summers, in 1930 and 1931. Before leaving New Mexico that third summer, she mailed a barrel of bones to New York so that she could continue to work on south-western pictures. In her words, 'I had to go home – what could I take with me of the country to keep me working on it? I had collected many bones and finally decided that the best thing I could do was to take with me a barrel of bones – so I took a barrel of bones.'

[80] Beginning in 1931, O'Keeffe made a series of paintings of animal skulls. The patriotic palette of one of these pictures, *Cow's Skull: Red, White, and Blue*, is distinctive. O'Keeffe later explained:

> When I arrived at Lake George I painted a horse's skull – then another horse's skull and then another horse's skull. In my Amarillo days cows had been so much a part of that country I couldn't think of it without them. As I was working I thought of the city men I had been seeing in the East. They talked so often of writing the Great American Novel – the Great American Play – the Great American Poetry. I am not sure that they aspired to the Great American Painting. Cézanne was so much in the air that I think the Great American Painting didn't even seem a possible dream ... I was quite excited over our country and I knew that at that time almost any one of those great minds would have been living in Europe if it had been possible for them. They didn't even want to live in New York – how was the Great American Thing going to happen? So as I painted along on my cow's skull on blue I thought to myself, 'I'll make it an American painting. They will not think it great with the red stripes down the sides – Red, White, and Blue – but they will notice it.'

It seems indisputable that *Cow's Skull: Red, White, and Blue* was calculated to provoke and to cast O'Keeffe as an emphatically national artist. Many Americans, including Charles Sheeler, Marsden Hartley, John Marin, Charles Demuth, Joseph Stella and Alfred Stieglitz had already celebrated American industry and nature in their art in the 1920s, although the xenophobic writings of nationalist art critics such as Thomas Craven assailed American modernists for their elitism and subservience to European models. In a statement reminiscent of O'Keeffe's, Craven wrote, 'The world has paid a heavy penalty for Cézanne's genius.'

◀ O'Keeffe on the Portal at the Ghost Ranch.

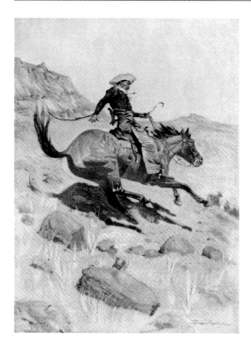

77
Frederic Remington (1861–1909)
The Cowboy, 1902
Oil on canvas
102.2 × 68.9 cm (40 ¼ × 27 ⅛ in)
Amon Carter Museum of American
Art, Fort Worth

THE MYTH OF THE AMERICAN WEST

In selecting a cow's skull as subject matter, O'Keeffe cannily harnessed one of the myths that has struck a deep chord in the American psyche. The phrase 'American West' summons an age of heroic individualism, a testosterone-drenched domain populated by brutal lawmen like Wyatt Earp, brave cowboys and marauding 'Indians' – traditional opponents of the cowboys and cattle ranchers.

[77]

If *Cow's Skull: Red, White, and Blue* announces itself as a pure and cohesive distillation of American culture, it is enriched by an unexpected dissonance. The forbidding skull and the patriotic background jostle with one another, like a meeting of Edvard Munch and John Philip Sousa. Paintings of skulls did not conform to traditional notions of femininity, and, as the art historian Wanda Corn has argued, these works were part of O'Keeffe's continuing effort to refashion her public persona, as she had earlier with her depictions of skyscrapers. This was another way for her to 'masculinize' her art, drawing attention to herself as a serious female artist in an art world of men.

Appropriately, having the freedom to remake oneself, to start afresh, is also central to the myth of the American West. O'Keeffe's newly formed masculine persona is presented more insistently in photographs Ansel Adams took of her picking up the bones of a cow, which appeared in an article about her in *Life* magazine in February 1938. One writer later commented that she was 'a rather terrifying young woman bent on grim research into the mysteries of death in the desert'.

HISPANIC INFLUENCES

In autumn 1931, combining her own genres, O'Keeffe painted several skull pictures that include bright artificial flowers. She was impressed with the gaudy handmade flowers she found in New Mexico, especially in the small Hispanic cemeteries: 'You could buy artificial flowers in all the little towns … they were beautiful things, so simple.'

[81] For eastern American viewers unfamiliar with the imagery of the Hispanic tradition of the Day of the Dead, paintings like *Horse's Skull with Pink Rose* would have appeared slightly bizarre. Indeed, the images led one critic to scold O'Keeffe for producing pictures laden with a 'perverse humor'.

SOLACE IN NATURE

In February 1933, O'Keeffe was admitted to a psychiatric hospital in Manhattan, where she stayed for about two months, severely depressed, perhaps because of her deteriorating relationship with Stieglitz. She stopped painting for the next thirteen months, during which time she took two long trips with friends to Bermuda. Her second stay there yielded a series of beautifully observed charcoal drawings of banana trees and their flowers.

O'Keeffe wrote, 'Off to one side of the house was a large grove of banana trees in flower … It was too hot to work long outside and I never took a flower into the house. I didn't like to cut it.' Akin to some of her detailed still lifes of feathers, bones and bowls of the 1930s, her Bermuda drawings are quite

[82] traditional, essentially about grappling with the corporeal. *Banana Flower*, for instance, contains a marvellous contrast between the smooth lower petals and the complicated jumble of dying petals above. Although these drawings may be seen as tinged with melancholy, they also emblematize O'Keeffe's view of nature as a place of solace and a bulwark against personal travails.

SOUTHWESTERN SURREALISM

In June 1934 O'Keeffe returned to New Mexico. In August she discovered Ghost Ranch, a 'dude' ranch for the entertainment of wealthy easterners, set in brilliantly coloured 'badlands' to the west of Taos. She fell in love with the place and spent most of her summers there, eventually buying a house on the property in 1940. O'Keeffe principally painted landscapes there, but some of the Ghost Ranch works veer into the territory of the fantastical. For instance, in summer 1935, increasing the complexity of her earlier imagery inspired by

[83] the Day of the Dead, she painted *Ram's Head, White Hollyhock-Hills*.

While several critics were unsure what to think of her portrayals of floating skulls, others recognized that this was the desert viewed through the prism of Surrealism. Salvador Dalí was extremely popular in America, and his other-worldly fantasies are often set in arid landscapes, however she may also have

[78] been thinking of the Belgian Surrealist René Magritte (1898–1967), who sometimes pictured alien floating forms in a hard, clear light.

Conjured apparitions can too easily become kitsch, yet O'Keeffe took Surrealism and turned it to her own purpose: her depictions of skulls hovering above the desert cannot be fully understood without seeing them as a manifestation of her earlier depression and battles with Stieglitz. Indeed, the paintings sublimate bitterness. Invoking African masks that embody menacing spirits or shamans in the guise of animals, they seem to warn the viewer to stay away.

Works like *Ram's Head, White Hollyhock-Hills* and *Summer Days* include flowers that O'Keeffe found in the desert or grew in her garden at Ghost Ranch. She enlivened *Summer Days* by placing the sunflower slightly to the right of centre within a composition that is otherwise quite symmetrical. As her signature subject, the flowers remind the viewer of who painted them, but they also provide a moving counterpoint to the skulls, juxtaposing the ephemeral and the eternal, the quick and the dead.

[84]

THE SYMBOLISM OF BONES

While paintings like *From the Faraway, Nearby* can be seen as bleakly symbolizing the American West, they simultaneously (and peculiarly) convey great energy. As O'Keeffe said about the skulls and bones, 'To me they are strangely more living than the animals walking around – hair, eyes and all with their tails twitching. The bones seem to cut sharply to the center of something that is keenly alive on the desert even though it is vast and empty and untouchable – and knows no kindness with all its beauty.'

[85]

78
René Magritte (1898–1967)
Voice of Space (La voix des airs), 1931
Oil on canvas
72.7 × 54.2 cm (28 ⅝ × 21 ⅜ in)
Peggy Guggenheim Collection, Venice

O'Keeffe's portrayals of floating skulls equally heroicize artistic vision. As Marsden Hartley wrote in 1936 about her skull scenes, '[they] portray the journey of her own inner states of being'. Those paintings construct her as someone who exists far above the everyday and who is capable of conjuring new worlds, someone willing to confront an implacable death.

Successfully transforming animal skulls into symbols of the untrammelled imagination and self-knowledge, these scenes evoke the visions of hermit saints in the desert who saw a land lit by revelation. O'Keeffe, who was educated in a Catholic school, would have remembered how in the Bible the desert is often described as a place where angels and demons can appear, a domain for odysseys of spiritual discovery in which the worlds of earth and heaven and hell collide. Thus, with her paintings of skulls, she sought to deepen her world view by exploring the interconnectedness of the natural and spiritual realms.

RETURN TO ABSTRACTION

In the 1940s, O'Keeffe's paintings of floating skulls gave way to depictions of pelvises and the horns of rams and goats, alongside a renewed interest in abstraction, one that would dominate her late output. These pictures are more abstract than the skulls, often with little or no sense of context. They are still paeans to the enduring, but works such as *Pelvis with Distance I* and *Goat's Horn with Red* present bones as, almost literally, a lens or aperture through which to view the world.

During World War II, O'Keeffe wrote that 'when I started painting the pelvis bones I was most interested in the holes in the bones – what I saw through them – particularly the blue from holding them up in the sun against the sky as one is apt to do when one seems to have more sky than earth in one's world ... They were most wonderful against the blue – that blue that will always be there as it is now after all man's destruction is finished.' O'Keeffe transmuted bones into numinous portals linking earth and heaven.

LANDSCAPES OF ENDURANCE

O'Keeffe's depictions of pelvic bones again demonstrate her interest in European avant-garde art, this time biomorphism. In the 1930s and 1940s artists like Henry Moore (1898–1986), Barbara Hepworth (1903–1975), Pablo Picasso (1881–1973), Alexander Calder (1898–1976) and David Smith (1906–1965) rendered the pre-modern in the form of bones – as did the American Clyfford Still (1904–1980).

The flat-topped blue mountain in the lower background of *Pedernal – From the Ranch #1* represents Pedernal Mountain – like bones, an example of an enduring form. O'Keeffe had a good view of the mountain from her house. She cherished it and painted it nearly thirty times, similarly to Cézanne painting Mont Sainte-Victoire. In the 1930s through to the 1950s, O'Keeffe

[86]
[87]

[79]

[88]

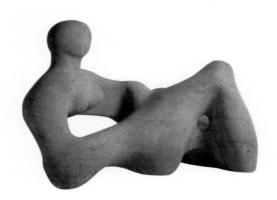

79
Henry Moore (1898–1986)
Recumbent Figure, 1938
Green Hornton stone
88.9 × 132.7 × 737cm
(35 × 52 ¼ × 290 ¼ in)
Tate, London

produced numerous landscapes, many based on views from around Ghost Ranch. Together, these paintings form a remarkable portrait of a place, rather like Monet's paintings of Giverny or Winslow Homer's depictions of Prout's Neck, Maine.

O'Keeffe's depictions of the desert from the 1930s and 1940s reinvented and revivified the myth of New Mexico. The image of the state as an exotic, pre-modern land of Native American dances, ancient ruins and Spanish colonial churches first crystalized in the early twentieth century with the tourist industry. O'Keeffe's renderings of Ranchos Church participated in this discourse, but her later portrayals of the desert shifted that myth into something more otherworldly. It is hard to imagine 'New Mexico' today, as ensconced in the popular imagination, without the pictures of O'Keeffe.

► FOCUS ⑧ GHOST RANCH, P.114

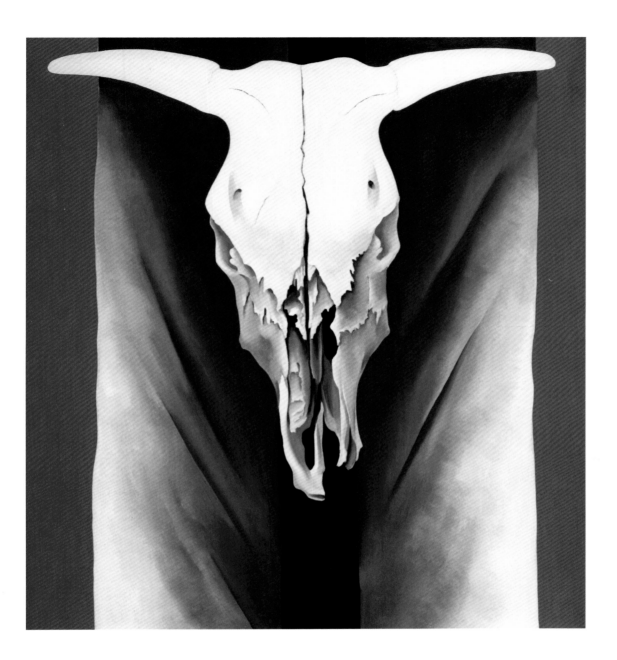

80
Cow's Skull: Red, White, and Blue, 1931
Oil on canvas
101.3 × 91.1 cm (39 ⅞ × 35 ⅞ in)
The Metropolitan Museum of Art, New York

The shape of the skull in this painting recalls a
crucifix. The allusion to suffering is amplified by the
split down the middle of the skull. O'Keeffe may
have meant this to acknowledge not only the violent
history of the American West but also the suffering
of New Mexico's impoverished Hispanic population.

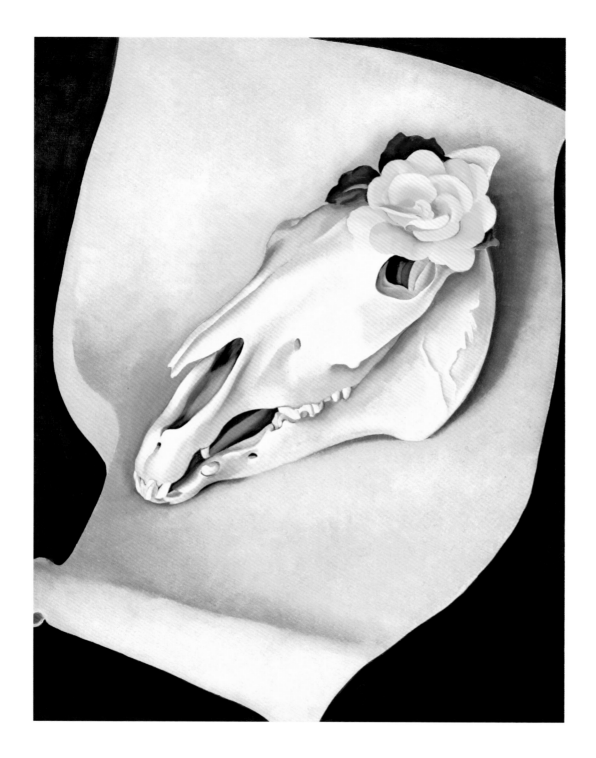

81
Horse's Skull with Pink Rose, 1931
Oil on canvas
101.6 × 76.2 cm (40 × 30 in)
Los Angeles County Museum of Art

82
Banana Flower, 1934
Charcoal on paper
55.2 × 37.5 cm (21 ¾ × 14 ¾ in)
The Museum of Modern Art, New York

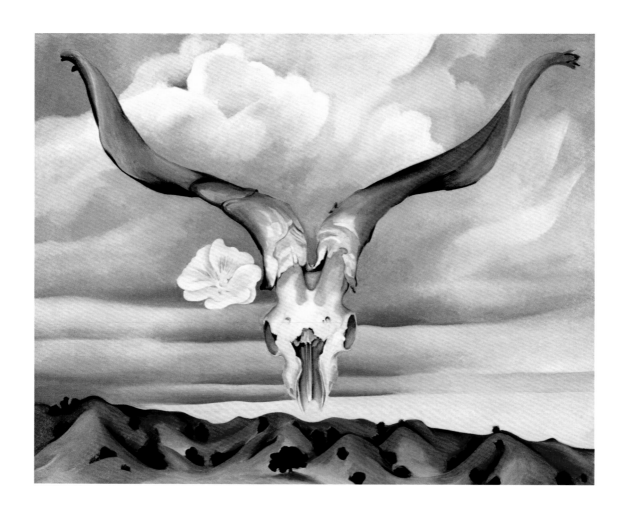

83
Ram's Head, White Hollyhock-Hills, 1935
Oil on canvas
76.2 × 91.4 cm (30 × 36 in)
Brooklyn Museum, New York

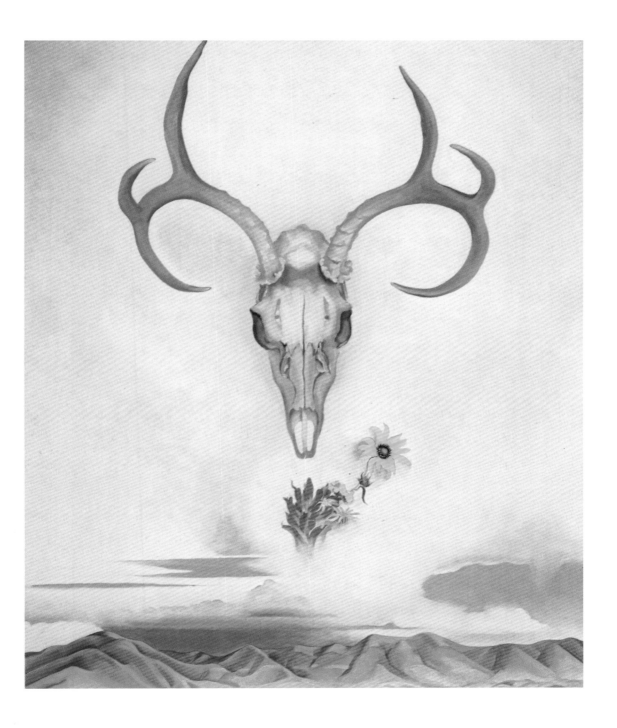

84
Summer Days, 1936
Oil on canvas
91.4 × 76.2 cm (36 × 30 in)
Whitney Museum of American Art, New York

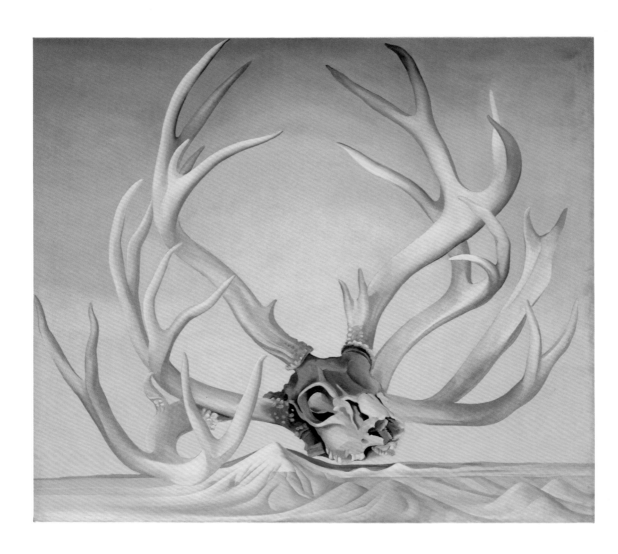

85
From the Faraway, Nearby, 1937
Oil on canvas
91.4 × 101.9 cm (36 × 40 ⅛ in)
The Metropolitan Museum of Art, New York

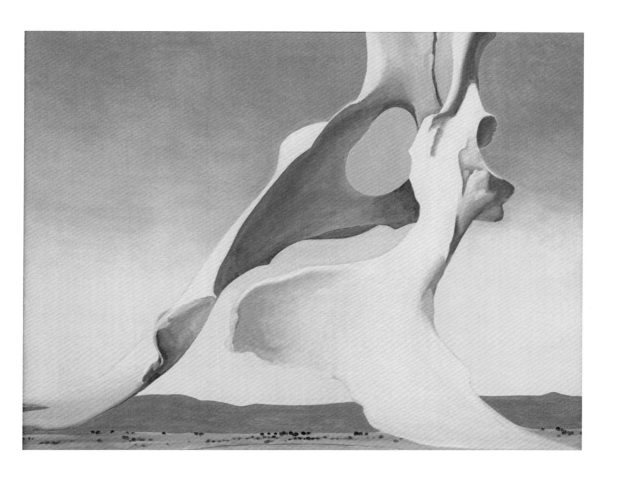

86
Pelvis with Distance I, 1943
Oil on canvas
60.6 × 75.6 cm (23 ⅞ × 29 ⅞ in)
Indianapolis Museum of Art

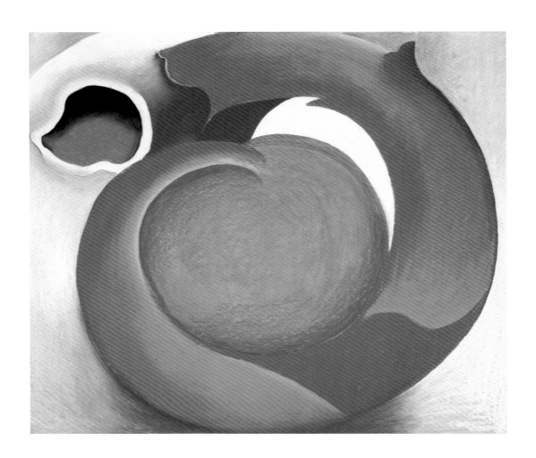

87
Goat's Horn with Red, 1945
Pastel on paper
70.7 × 80.4 cm (27 ⅞ × 31 ⅝ in)
Hirshhorn Museum and Sculpture Garden,
Smithsonian Institution, Washington, DC

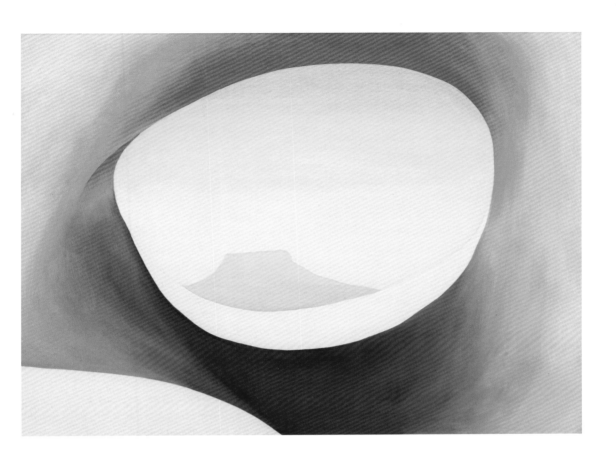

88
Pedernal – From the Ranch # 1, 1956
Oil on canvas
76.2 × 101.6 cm (30 × 40 in)
Minneapolis Institute of Arts

Pedernal Mountain is visible from O'Keeffe's
home and at over 3 kilometres (1 ¾ miles) it
is the tallest point in the Ghost Ranch area.
She painted it many times, later saying, 'It's
my private mountain. It belongs to me. God
told me if I painted it enough, I could have it.'

FOCUS ⑧

GHOST RANCH

Ghost Ranch is dominated by coloured sandstone buttes that were formed 220 million years ago, when the area was covered by a large inland sea. Paintings such as *My Backyard* [92] and *Part of the Cliff* [98] convey a sense of geological time and how the formations are being continually eroded by wind and water. O'Keeffe made the buttes look as impermanent as melting ice cream or flesh.

The same is true of *Purple Hills No.II* [90] and *Red Hills and Bones* [96], in which the landscape appears both primordial and body-like. *Gerald's Tree I* [91] also contains corporeal elements and is reminiscent of a dancing figure (it was dedicated to her friend Gerald Heard, who had supposedly danced round it). In the 1930s, many American artists, including Grant Wood [89] and Alexander Hogue, similarly anthropomorphized the landscape, evoking Mother Earth.

While at Ghost Ranch in the 1930s, O'Keeffe also created a series of portrayals of the Chama River. The painting *Chama River, Ghost Ranch* [93] conveys the cool river in the midst of a scorching and parched desert landscape. During those years, O'Keeffe repeatedly painted two places that she considered magical: the 'Black Place' and the 'White Place'. She sometimes camped at the Black Place, which is located about 240 km (149 miles) north-west of Ghost Ranch, and noted that 'it looks like a mile of elephants – grey hills all about the same size with almost white sand at their feet'.

Grey Hills [95], for example, gives this spare landscape life, as if its hills were indeed slumbering giant animals. O'Keeffe's renderings of the Black Place grew increasingly abstracted in the 1940s. Reminiscent of her earlier dramatic depictions of Texas [17], works such as *Black Place II* [97] conjure the benighted start of the world.

The White Place is located about 30 km (18 ¾ miles) south of Ghost Ranch. It is easy to see why she was drawn to these strange gypsum formations, because they have already reduced the world to crisp edges and positive and negative spaces. O'Keeffe's painting *From the White Place* [94] crops the rock formations, turning them into a series of abstracted forms.

The White Place is just across a valley from the tiny village of Abiquiu. In 1945, O'Keeffe bought an abandoned, colonial-era hacienda there from the Catholic Church and then had it rebuilt. This house sits at a lower elevation than her home at Ghost Ranch and had water rights for a large garden. Beginning in 1949, she spent each winter and spring in the Abiquiu house and her summers at Ghost Ranch.

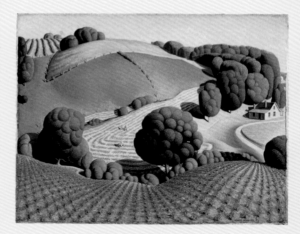

89
Grant Wood (1891–1942)
Young Corn, 1931
Oil on masonite panel
60.9 × 75.9 cm (24 × 29 ⅞ in)
Cedar Rapids Museum of Art

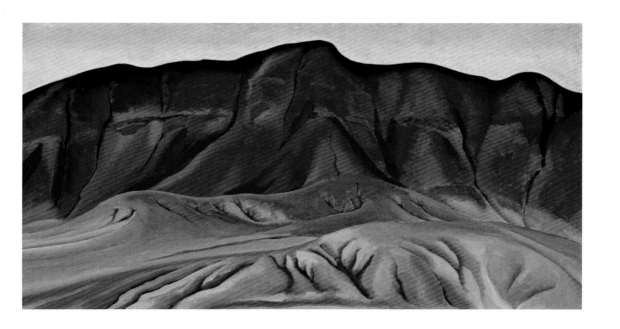

90
Purple Hills No. II, 1934
Oil on canvas
36.2 × 76.8 cm (14 ¼ × 30 ¼ in)
Georgia O'Keeffe Museum, Santa Fe

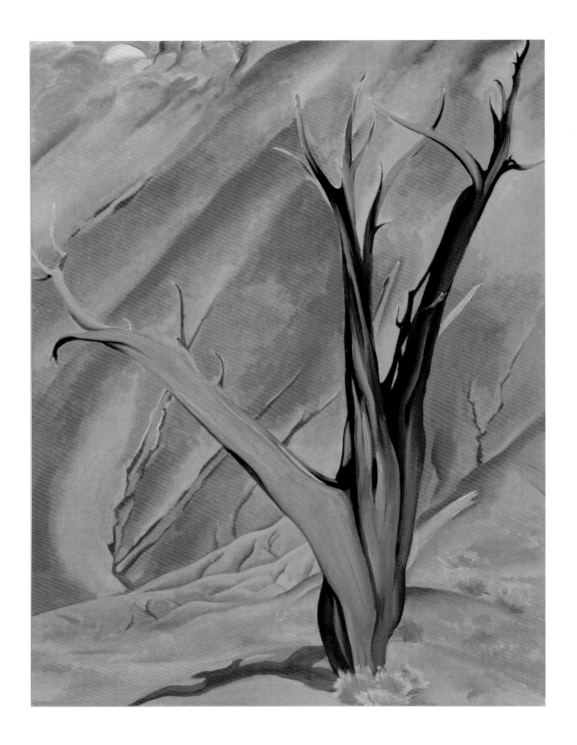

91
Gerald's Tree I, 1937
Oil on canvas
101.6 × 76.2 cm (40 × 30 in)
Georgia O'Keeffe Museum, Santa Fe

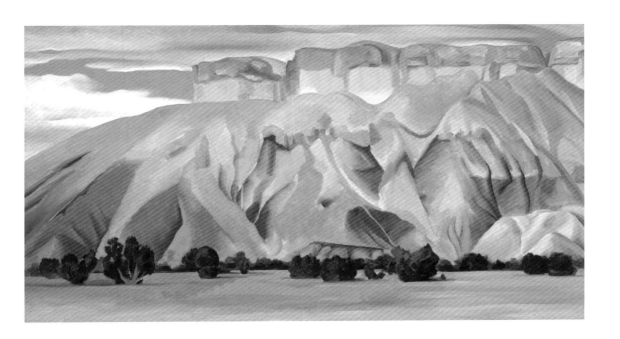

92
My Backyard, 1937
Oil on canvas
50.8 × 91.4 cm (20 × 36 in)
The New Orleans Museum of Art

93
Chama River, Ghost Ranch, 1937
Oil on canvas
77.5 × 41.9 cm (30 ½ × 16 ½ in)
New Mexico Museum of Art, Santa Fe

94
From the White Place, 1940
Oil on canvas
76.2 × 61 cm (30 × 24 in)
The Phillips Collection, Washington, DC

95
Grey Hills, 1941
Oil on canvas
51 × 76.2 cm (20 × 30 in)
Indianapolis Museum of Art

96
Red Hills and Bones, 1941
Oil on canvas
75.6 × 101.6 cm (30 × 40 in)
Philadelphia Museum of Art

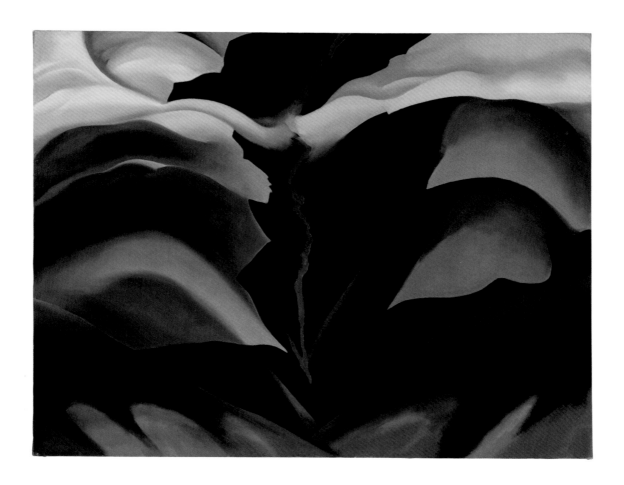

97
Black Place II, 1944
Oil on canvas
60.6 × 76.2 cm (23 ⅞ × 30 in)
The Metropolitan Museum of Art, New York

O'Keeffe's cherished 'Black Place' is in New
Mexico's Bisti Badlands, which is an area
that is populated by the Navaho. An arid,
blasted landscape, her views of it in 1944
may have reflected the ongoing destruction
of World War II. Starting in the late 1930s,
O'Keeffe painted many landscapes (in New
Mexico, Yosemite, and Hawaii) that similarly
show a primordial earth split vertically.

98 ►
Part of the Cliff, 1946
Oil on canvas
91.4 × 50.8 cm (36 × 20 in)
Georgia O'Keeffe Museum,
Santa Fe

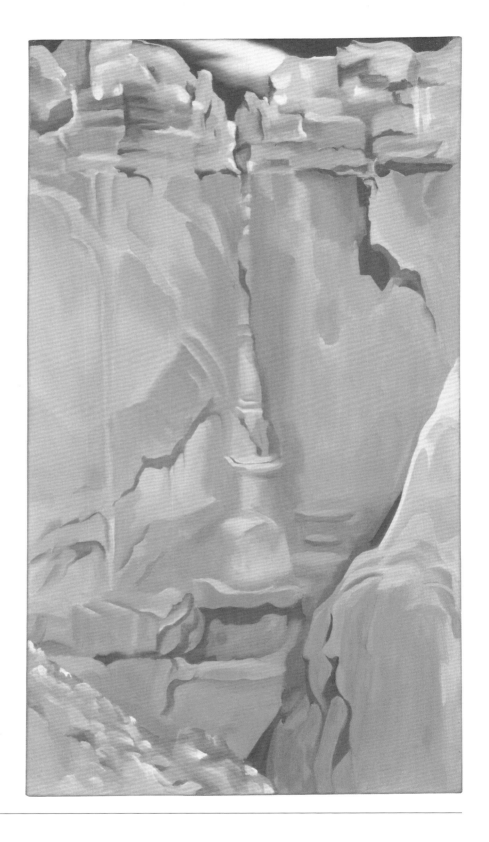

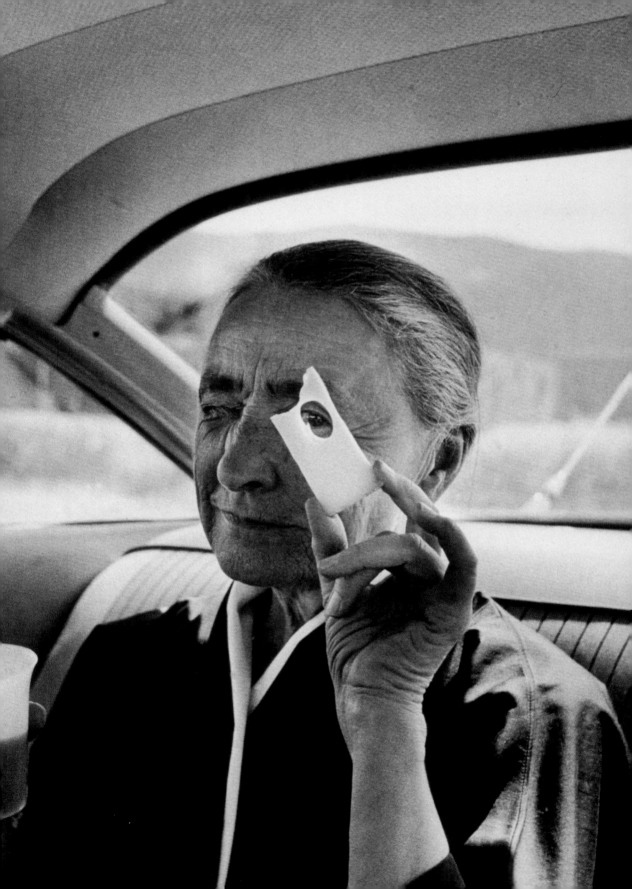

THE LATE WORK

[100]

Stieglitz died in New York of a massive stroke on 13 July 1946. O'Keeffe's moving painting *Bare Tree Trunks with Snow* depicts the trees at Lake George that had been a source of inspiration for him as a photographer and she supposedly scattered his ashes at the base of one of these trees. As a tribute to Stieglitz, the painting resembles her earlier homage to D. H. Lawrence, but the later work is, appropriately, quite sombre. One feels the cold, and the snow resembles a blanket for the dead. The cropped tree trunks call to mind the grave markers shaped like tree stumps that are commonplace in Victorian cemeteries. *Bare Tree Trunks with Snow* is, therefore, a moving meditation on love, loss and forgiveness, a way for O'Keeffe to come to terms with Stieglitz's end. She spent the next two years settling his estate, dividing his extraordinary art collection between thirteen American museums. In 1949, she moved permanently to her two houses in New Mexico.

THE WALL PAINTINGS

O'Keeffe's paintings from the 1950s and 1960s have mostly been neglected by scholars. Although not her best body of work, several extraordinary pieces date from this period. For instance, in the early 1950s, she produced a memorable group of pictures of her Abiquiu and Ghost Ranch houses. *Wall with*
[101-3]
Green Door, *Black Door with Red* and *Patio Door with Green Leaf* all portray a courtyard wall and door at her Abiquiu house. The austere design of the door was one of the main reasons she bought the house.

 Black Door with Red is among the largest canvases O'Keeffe ever produced. This new, expanded scale suggests that she was aware of the Abstract Expressionists, whose vast abstractions she would have known from magazines. Likewise, with these paintings of walls she returned to a high degree of abstraction, but they also introduce a novel geometric purity and an utter flatness that reveal her familiarity with the severe art of Barnett Newman (1905–1970), though their animating spirit is as much Matisse.

 In short, the wall paintings were calculated to seem current. It is as though O'Keeffe were following the exhortations of the well-known contemporary critic Clement Greenberg, who complained that her work was decorative and superficial. He thought that, above all, art should be about art, and extolled flatness in painting as a desirable means to expose the materiality of the picture plane.

 O'Keeffe's wall paintings can also be seen as autobiographical, in that they express her disciplined sense of order and her love of privacy. In the final part of her life O'Keeffe became increasingly reclusive. She had close friends, some of whom visited her in New Mexico, but she was also misanthropic.

◄ O'Keeffe looking through a piece of cheese, Abiquiu, 1960.

She commented: 'I wish people were all trees and I think I could enjoy them then' and 'I know that I do not wish to try to live among many people – they tire me more than anything.'

ORGANIC GEOMETRIC ABSTRACTS

In the late 1950s, O'Keeffe formulated several striking abstracts that are dominated by a group of semi-translucent vertical forms. Coupling the geometric and the organic, paintings such as *Blue II* seem to have been inspired by the prismatic abstracts of the early twentieth-century Czech painter František Kupka (1871–1957). Kupka's works were then being trumpeted by Alfred Barr at the Museum of Modern Art in New York.

[104]

 This suggests that, during this late phase of her career, O'Keeffe was looking broadly for inspiration. These geometric abstracts also show her ongoing interest in rendering mysterious interior spaces. *Blue II* resembles some fantastical cave entrance, with a rectangular open tomb inside.

LADDER METAPHOR

O'Keeffe often used a handmade ladder to climb to the roof of her Ghost Ranch house. In *Ladder to the Moon*, which reflects a whimsical painting, *Dog Barking at the Moon*, by Joan Miró, she pictured the ladder (an ancient Biblical symbol) as a link between the distant Pedernal Mountain and the moon, an emblem of lightness and transcendence. This is another example of her ruminations on making art as a retreat from the world, a journey leading to higher truths.

[105]

[99]

► FOCUS ⑨ TRAVEL AND TRANSCENDENCE, P.134

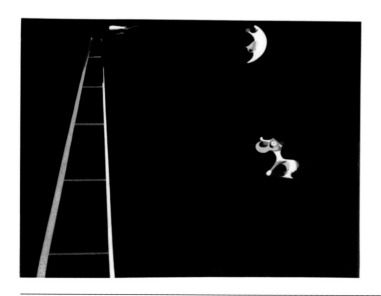

99
Joan Miró (1893–1983)
Dog Barking at the Moon, 1926
Oil on canvas
73 × 92.1 cm
(28 ¾ × 36 ¼ in)
Philadelphia Museum of Art

LAST YEARS

In 1968, while she was still an active artist, O'Keeffe's central vision began to fail due to macular degeneration. By 1971 she retained only her peripheral sight. Two years later she met the potter and sculptor Juan Hamilton, who became her closest friend and adviser.

By 1977, Hamilton would replace Doris Bry as O'Keeffe's longtime agent; this led to a bitter and lengthy court battle, eventually resolved in Hamilton's favour. Owing to O'Keeffe's blindness and shortness of memory, she left her two beloved homes and moved, along with Hamilton and his family, into a house in Santa Fe. She died in a Santa Fe hospital on 6 March 1986, and afterwards her ashes were scattered by Hamilton on Pedernal Mountain.

ASSESSING HER LEGACY

It is almost impossible to imagine the history of American art without O'Keeffe. In order to assess her achievement, it is necessary to discard the narrative of modernism as a neat evolutionary procession of styles extending from realism to abstraction. O'Keeffe's achievement testifies to the distorting nature of that paradigm. Such a 'history' of modernism has tended to cast beautiful and decorative art in a negative light, as opposed to efforts involving conceptual difficulty and political or disturbing content. Although aware of European avant-garde art and sometimes selectively adapting its trends to her own purposes, O'Keeffe never felt beholden to its orthodoxies.

Viewing her universe mainly through the prism of gender also does it a disservice. As someone who was continually pigeonholed as a woman painter, O'Keeffe wanted her work to transcend gender. The range of her prodigious talent is great, and ultimately her art is about the powers of the imagination.

Nevertheless, the cacophony of modern life has also contributed to the enduring relevance of her contribution. She constantly challenges us to slow down and pay attention to the smallest aspects of the natural world, once describing each seashell she was painting as 'a beautiful work in itself'.

O'Keeffe wants us to lose ourselves in the contemplation of beauty. Like the works of her contemporaries Edward Weston, Ansel Adams, Henry Moore and Alexander Calder, her paintings affirm the importance of nature as a source of aesthetic inspiration and self-knowledge. O'Keeffe would have applauded the nineteenth century American transcendentalist Henry David Thoreau's observation about snowflakes: 'I should hardly admire [them] ... more if real stars fell and lodged on my coat.' Her aim was to communicate the importance of seeing nature afresh, and finding wonder in it.

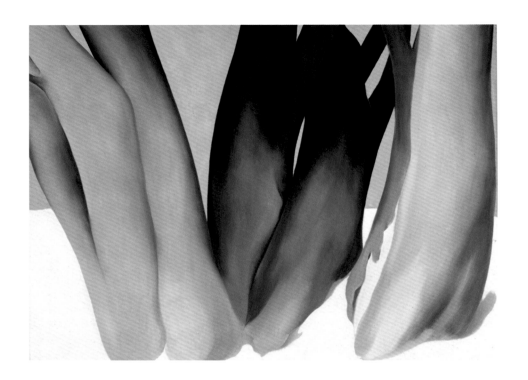

100
Bare Tree Trunks with Snow, 1946
Oil on canvas
74.9 × 100.3 cm (29 ½ × 39 ½ in)
Dallas Museum of Art

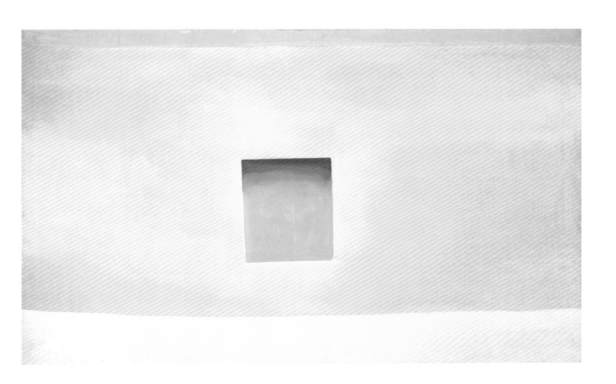

101
Wall with Green Door, 1953
Oil on canvas
76.2 × 122.6 cm (30 ¼ × 48 ¼ in)
Corcoran Gallery of Art, Washington, DC

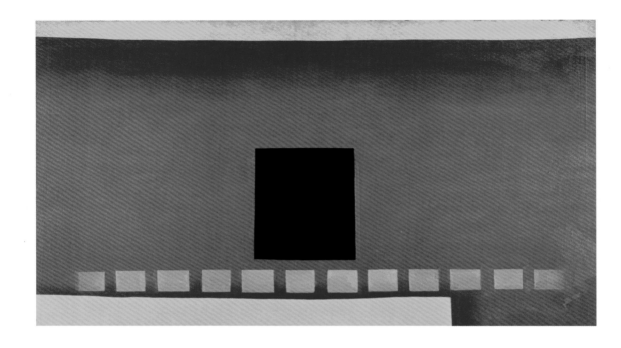

102
Black Door with Red, 1954
Oil on canvas
121.9 × 213.4 cm (48 × 84 in)
Chrysler Museum of Art, Norfolk, Virginia

In this portrayal of the courtyard wall in her
Abiquiu home, O'Keeffe once again pictured
its black wooden door as a dark void, almost
as if it were a mysterious portal. The painting
moves the square tiles on the ground up onto
the vertical wall to create a composition of
changing rectangular forms.

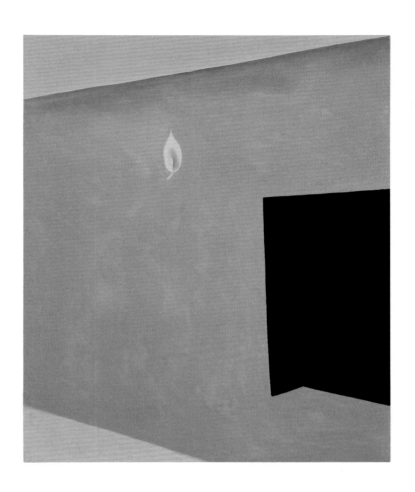

103
Patio Door with Green Leaf, 1956
Oil on canvas
91.4 × 76.2 cm (36 × 30 in)
Georgia O'Keeffe Museum, Santa Fe

104
Blue II, 1958
Oil on canvas
76.2 × 66 cm (30 × 26 in)
Georgia O'Keeffe Museum, Santa Fe

105 ►
Ladder to the Moon, 1958
Oil on canvas
102.1 × 76.8 cm (40 × 30 in)
Promised gift of Emily Fisher Landau,
Whitney Museum of American Art, New York

FOCUS ⑨

TRAVEL AND TRANSCENDENCE

O'Keeffe always delighted in the challenge of distilling and abstracting form. This is epitomized in her paintings of the road to Santa Fe and Ghost Ranch, which can be seen from her house in Abiquiu. Works such as the hypnotic *Winter Road I* [109], which at first glance looks like an effortless doodle, are steeped in the tradition of Chinese calligraphic brush paintings – by this time she owned a sizeable library on Asian art.

Winter Road I also reflects a new interest in travel. In the 1950s and 1960s, O'Keeffe visited Asia twice, as well as Peru, the Yucatán, Spain, France, Greece and Egypt, and this painting embodies a sense of discovery and freedom. In its use of line alone, it bears some resemblance to the drip paintings of Jackson Pollock [106],

although O'Keeffe disliked Pollock's work. Along with the other so-called Action Painters, he offered the viewer a tactile record of the artistic process and a vigorous, unruly sense of spontaneity. In stark contrast, *Winter Road I*, lyrical and austere, refracts the world through line, reminding us that O'Keeffe was at heart a formalist, whose aesthetic roots were in Art Nouveau and Symbolism.

Her many airplane journeys encouraged her to produce a series of abstract representations of rivers, such as *It was Blue and Green* [108]. These illustrate once more both her unabashed allegiance to beauty and her exploration of the awe-inspiring. Another example, *It was Red and Pink* [111], shows that during this period she clearly had one eye on the radiant abstract

106
Jackson Pollock
(1912–1956)
Number 29, 1950, 1950
Black and aluminium
enamel paint, expanded
steel, string, beads, coloured
glass and pebbles on glass
121.9 × 182.9 cm
(48 × 72 in)
National Gallery of Canada,
Ottawa

paintings of Mark Rothko [107], an artist she praised publicly.

In the spring of 1956 O'Keeffe visited Peru and was especially impressed by the Andes and the Inca ruins of Machu Pichu. This excursion led to a series of works including *Machu Pichu I* [110], which turns the mountainsides into a ravishing flood of colours. If it invokes Paul Gauguin's lush scenes of Tahiti (without the languorous nudes), it also bears a strong resemblance to the contemporary, rhapsodic paintings of Helen Frankenthaler (1928–2011).

Between 1962 and 1965 O'Keeffe produced a series of views of clouds [112, 114], pictured from the perspective of an airplane. These became increasingly large in scale, thus echoing new currents in post-World War II American art as well as the earlier Mexican muralists. Monet's large water lilies also come to mind.

Recalling some of O'Keeffe's early West Texas scenes [15], the cloudscapes also look back to Stieglitz's extraordinary photographs of clouds, his Equivalents series [113]. Both artists employed clouds as a reflection of self, but whereas his photographs emphasize the distinctiveness of each cloud, she transforms them into cohesive patterns of oval forms, like stepping stones that one could walk across. These paintings exude a feeling of airborne euphoria. Halfway between vision and reality, they can be seen as a metaphor for O'Keeffe's conception of artistic creation as a state that transcends ordinary life.

107
Mark Rothko (1903–1970)
Orange and Yellow, 1956
Oil on canvas
231.1 × 180.3 cm (91 × 71 in)
Albright-Knox Art Gallery, Buffalo

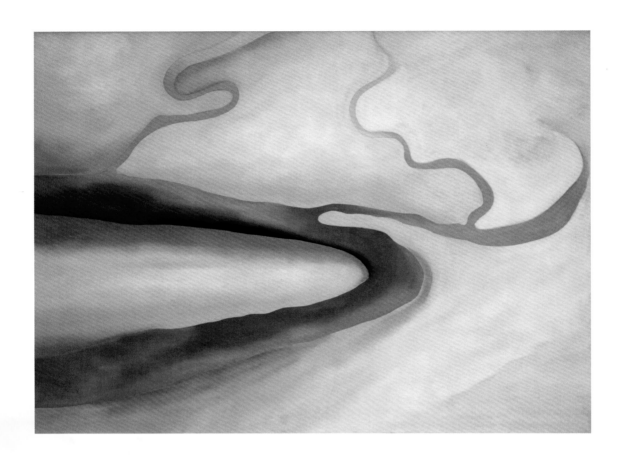

108
It was Blue and Green, 1960
Oil on canvas
76.3 × 101.6 cm (30 × 40 in)
Whitney Museum of American Art, New York

This painting was one of a group of renderings,
in charcoal and oil, of rivers as seen from an
airplane. Like her earlier close-up views of
flowers, these are meant to show nature anew,
depicted from a different point of view. It turns
the earth into a strange living form: the blood
veins of mother earth.

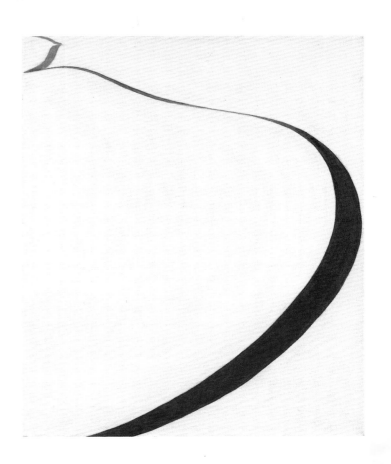

109
Winter Road I, 1963
Oil on canvas
55.9 × 45.7 cm (22 × 18 in)
National Gallery of Art, Washington, DC

110
Machu Pichu I, 1957
Oil on canvas
28.3 × 20.3 cm (11 ⅛ × 8 in)
Georgia O'Keeffe Museum, Santa Fe

111
It was Red and Pink, 1959
Oil on canvas
76.2 × 101.6 cm (30 × 40 in)
Milwaukee Art Museum

112
Above the Clouds I, 1962–1963
Oil on canvas
91.8 × 122.6 cm (36 ⅛ × 48 ¼ in)
Georgia O'Keeffe Museum, Santa Fe

113
Alfred Stieglitz
Equivalent 333, 1937
Gelatin silver print
9.2 × 11.8 cm (3 ⅝ × 4 ⅝)
Private collection

114
Sky Above the Flat White Cloud II, 1960–1964
Oil on canvas
76.2 × 101.6 cm (30 × 40 in)
Georgia O'Keeffe Musuem, Santa Fe

A flight to New Mexico inspired O'Keeffe to create a series of cloud paintings. Willfully decorative, these works present the clouds as something that should delight and inspire revelation. Several of these late works radically reduce the sky and clouds to vivid gradients and blocks of colour. The series possesses a sense of sublime transcendence and echoes O'Keeffe's belief that art should keep the everyday world at bay.

CHRONOLOGY

1887

Georgia Totto O'Keeffe is born on 15 November, on her family's farm near Sun Prairie, Wisconsin.

1905

O'Keeffe attends the School of the Art Institute of Chicago, where she takes a drawing and painting class as well as one on lettering. She also sits in on a survey of western art class. She receives an Honorable Mention for her work in the classes.

1907–8

She attends the Art Students League in New York, taking classes with William Merritt Chase and Kenyon Cox. In January 1908, O'Keeffe sees an exhibition of erotic watercolours by Auguste Rodin at Stieglitz's 291 gallery. In June, she is awarded the Art Students League's Still Life Scholarship. In the autumn of 1908, she stops painting and moves to Chicago to become a commercial artist.

1910

She abandons commercial art and moves to Charlottesville, Virginia, to join her mother.

1912

O'Keeffe enrols in Alon Bement's summer art course at the University of Virginia. In the autumn she begins a two-year job, teaching art at a high school in Amarillo, Texas.

1914

Teaching an art course at the University of Virginia in the summer, in the autumn she enrols at Columbia University Teachers College, New York. She visits an exhibition of Cubist works by Picasso and Braque at Alfred Stieglitz's 291 gallery.

1915

In the autumn, she starts teaching art classes at Columbia College in Columbia, South Carolina, and begins a series of abstract charcoals.

1916

She attends classes at Teachers College with Arthur Dow in the spring. Her mother dies in Charlottesville in early May. On 23 May, several of her abstract charcoal drawings are exhibited at the 291 gallery. In September she becomes head of the art department at West Texas State Normal College in Canyon.

1917

O'Keeffe's first solo exhibition opens 3 April, at the 291 gallery. In August, she holidays in New Mexico and Colorado with her sister Claudia.

1918

She arrives in New York City 10 June and begins a relationship with Stieglitz. Her father dies in Petersburg, Virginia, in November.

1919
O'Keeffe and Stieglitz stay most of the summer and autumn at the Stieglitz family's Lake George house, a ritual that continues for the next nine years.

1920
She visits York Beach, Maine, with Stieglitz in the spring. In the summer, she converts an old shed at Lake George into a studio, which she calls 'The Shanty'.

1924
In March, a show of O'Keeffe's work opens at The Anderson Galleries in New York, which was curated by Stieglitz. Some of the criticism includes sexual readings of her work. Stieglitz's divorce from his first wife is completed on 9 September. O'Keeffe and Stieglitz marry on 11 December.

1925
She moves into the Shelton Hotel in November and starts a series of paintings of New York City.

1926
In February, 'Fifty Recent Paintings by Georgia O'Keeffe' opens at the Intimate Gallery in New York.

1927
The first museum exhibition of her work opens 1 June at the Brooklyn Museum. She is hospitalized for breast surgery in July and December.

1929
O'Keeffe travels to Taos, New Mexico, with Rebecca Strand, spending five months with Mabel Dodge Luhan.

1930
She spends four months in Taos and ships a barrel of bones to New York.

1933
O'Keeffe is hospitalized in New York in February for severe depression and spends three months recuperating in Bermuda.

1935
In January, 'Georgia O'Keeffe: Exhibition of Paintings (1919-1934)' opens at Stieglitz's gallery An American Place, New York.

1939
In January, a show of O'Keeffe's oils and pastels opens at An American Place. That spring she visits Hawaii as a guest of the Dole Pineapple Company, producing a series of tropical landscapes.

1940
In June, O'Keeffe travels by car with Nacissa Swift (the meat-packing heiress) to New Mexico. In October she purchases the Ghost Ranch house and paints the Black Place and White Place. She returns to New York in December after Stieglitz suffers a minor heart attack.

1944

In January, 'Georgia O'Keeffe: Paintings–1943' opens at An American Place. In May and June, O'Keeffe spends more time at the Black Place; according to her agent Doris Bry, this site in New Mexico was the most sacred to her.

1945

She purchases in December her future home in the village of Abiquiu, which takes four years to restore.

1946

A retrospective of her work opens in May at the Museum of Modern Art, New York. Stieglitz dies of a stroke on 13 July.

1949

In June, she moves to New Mexico, where she will live for the rest of her life. To mark her leaving New York, she paints *Brooklyn Bridge*. After installing the Stieglitz Collection at Fisk University in Nashville, she moves into the Abiquiu house in December.

1951

In February, she travels to Mexico with Eliot Porter and meets Diego Rivera and Frida Kahlo.

1959

She flies to Hawaii, Asia, India, the Middle East and Italy. She produces many drawings and paintings of rivers that are inspired by her views from airplanes.

1963

O'Keeffe travels to Greece, Egypt and the Near East. She paints her iconic *Winter Road I*, and begins her series of cloud paintings.

1970

In October the Whitney Museum of American Art opens a retrospective of her work.

1973

O'Keeffe meets Juan Hamilton who becomes her beloved assistant. Owing to her failing vision, Hamilton soon teaches her how to make stoneware pots.

1984

She moves into Juan Hamilton's large family home in Santa Fe, allowing her to be closer to medical facilities.

1985

She receives the National Medal of the Arts from President Ronald Reagan.

1986

Georgia O'Keeffe dies in Santa Fe on 6 March, aged ninety-eight. A year later a retrospective of her work opens in November at the National Gallery of Art, Washington, DC.

1989

The Georgia O'Keeffe Foundation is established in May, preserving O'Keeffe's artistic legacy for public benefit.

FURTHER READING

Marcia Brennan, *Painting Gender, Constructing Theory: The Alfred Stieglitz Circle and American Formalist Aesthetics* (Cambridge, MA, 2001)

Anna C. Chave, 'O'Keeffe and the Masculine Gaze', *Art in America*, 78 (January 1990), pp. 114–24, 177, 179

Anna C. Chave, 'Who Will Paint New York?', *American Art*, 5 (Winter/Spring 1991), pp. 87–107

Wanda Corn, *The Great American Thing: Modern Art and National Identity, 1915–1935* (Berkeley, 1999)

Jack Cowart, Juan Hamilton and Sarah Greenough, *Georgia O'Keeffe: Art and Letters* (exh. cat., National Gallery of Art, Washington, DC, 1987)

Arthur Wesley Dow, *Composition: A Series of Exercises in Art Structure for the Use of Students and Teachers* (Garden City, NY, 1899)

Hunter Drohojowka-Philp, *Full Bloom: The Art and Life of Georgia O'Keeffe* (New York, 2004)

Charles C. Eldredge, *Georgia O'Keeffe: American and Modern* (exh. cat., Hayward Gallery, London, 1993)

Charles C. Eldredge, Julie Schimmell and William H. Treuttner, *Art in New Mexico 1900–1945: Paths to Taos and Santa Fe* (exh. cat., National Museum of American Art, Washington, DC, 1986)

Lloyd Goodrich and Doris Bry, *Georgia O'Keeffe* (exh. cat., Whitney Museum of American Art, New York, 1970)

Sarah Greenough, *Alfred Stieglitz: The Key Set: The Alfred Stieglitz Collection of Photographs* (exh. cat., National Gallery of Art, Washington, DC, 2002)

Sarah Greenough (ed.), *My Faraway One: Selected Letters of Georgia O'Keeffe and Alfred Stieglitz: Volume I, 1915–1933* (London, 2011)

Barbara Haskell (ed.), *Georgia O'Keeffe: Abstraction* (exh. cat., Whitney Museum of American Art, New York, 2009)

William Inness Homer, *Alfred Stieglitz and the American Avant-Garde* (Boston: New York Graphic Society, 1977)

Barbara Buhler Lynes, *Georgia O'Keeffe: Catalogue Raisonné*, 2 vols (London, 1999)

Barbara Buhler Lynes, *O'Keeffe, Stieglitz and the Critics, 1916–1929* (Ann Arbor, 1989)

Barbara Buhler Lynes and Carolyn Kastner, *Georgia O'Keeffe in New Mexico: Architecture, Katsinam, and the Land* (Georgia O'Keeffe Museum and the Museum of New Mexico Press, 2012)

Barbara Buhler Lynes, Lesley Poling-Kempes and Frederick W. Turner, *Georgia O'Keeffe and New Mexico: A Sense of Place* (exh. cat. Georgia O'Keeffe Museum, Santa Fe, 2004)

Georgia O'Keeffe, *Georgia O'Keeffe* (New York, 1976)

'Georgia O'Keeffe Turns Dead Bones to Live Art', *Life*, 4 (14 February 1938), pp. 28–30

Sarah Whitaker Peters, *Becoming O'Keeffe: The Early Years* (New York, 1991)

Anne Middleton Wagner, *Three Artists (Three Women): Modernism and the Art of Hesse, Krasner, and O'Keeffe* (Berkeley, 1996)

PICTURE CREDITS

LIST OF WORKS